WAYS OF LOOKING

Published in 2014 by Laurence King Publishing Ltd
361-373 City Road
London EV1V 1LR
United Kingdom
Tel: + 44 20 7841 6900
Fax: + 44 20 7841 6910
e-mail: enquiries@laurenceking.com
www.laurenceking.com

A catalogue record for this book is available from
the British Library

ISBN: 978-1-78067-193-2

Design: Jon Allan, TwoSheds Design
Picture Research: Peter Kent
Senior Editor: Robert Shore
Index: Elizabeth Wiggins

Printed in China

Front cover: Fiona Banner, Harrier, 2010,
BAe Sea Harrier aircraft, paint, 7.6 × 14.2 × 3.71 m.
© Tate, London 2013. Courtesy of the artist
and Frith Street Gallery
Back cover: Urs Fischer, you, 2007. Mixed media.
Dimensions variable. Courtesy of the artist and
Gavin Brown's enterprise. © the artist.
Photo by Ellen Page Wilson Photography

OSSIAN WARD

WAYS OF LOOKING

HOW TO EXPERIENCE CONTEMPORARY ART

TABLE OF CONTENTS

Jeppe Hein, Please Do
Not Touch, 2009,
neon tubes, transformers,
68 x 57.3 x 3 cm

CHAPTER 1:

AN INTRODUCTION TO LOOKING AGAIN

'ALL THEORY,
DEAR FRIEND,
IS GREY, BUT THE
GOLDEN TREE
OF ACTUAL LIFE
SPRINGS EVER
GREEN.'

GOETHE, FAUST, 1808

Planes fly high overhead, cars stream by. Phone screens flash, shop signs call out to us and adverts offer us their wares. Images jostle with each other, objects line up for inspection, while time marches on regardless. We don't stop to look at much anything nowadays.

With so many voices and visuals competing for our attention, it's a wonder we can filter out any sense in our daily existences at all, especially given our near-continuous interactions with the internet, the television, the smartphone, the social-media timeline and the twenty-four-hour news stream, not to mention the general claxons and clamour of city noise. More than ever before, looking has become a matter of Darwinian survival – only the strongest images make the grade, and even then we only give a cursory glance to what we think we're seeing.

Contemporary art, like contemporary life, is now a similarly fast-moving landscape, in which artists make use of, or refer to, everything in our purview and anything else imaginable besides. Much of our culture, infused as it is with the same multisensory slap-in-the-face shorthand as our hurried existences, can be difficult to look at or get a grip on. Even making simple eye contact with today's art can be tough. Contemporary works of art – for the purposes of this book, I have chosen to define 'contemporary' as

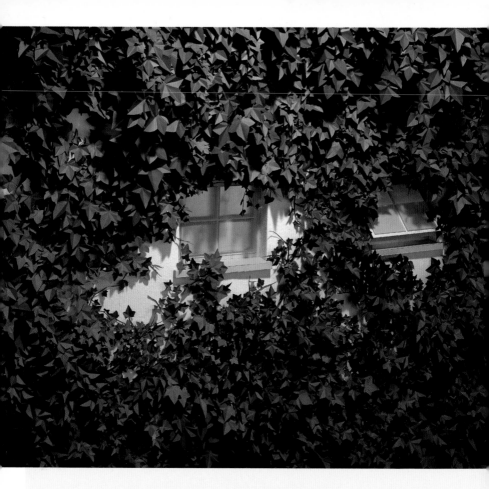

anything made since 2000 – may have no obvious focal point, they may be scattered across several rooms in a gallery, or last several hours, or you may even be enveloped in one, unable to figure out where it starts and stops. The old rules of not touching a work of art or of reverentially paying homage to each picture in a state of quiet awe are now gone too and you might be expected to perform, interact with or complete the piece in front of you.

Even traditional artistic media hardly ever do what we expect of them anymore. Paintings might not be readable as individual pictures and could be serial in nature, with artists creating narratives or aesthetic systems that develop or unfurl over many canvases, often as an installation or a constellation of related images. Sculptures are no longer simply shiny bronzes or figures on plinths, but neither do they necessarily look like the radically reduced steel and glass objects made by Minimalist artists in the 1960s and '70s. In fact, contemporary artists are just as likely to disguise sculptural matter as everyday objects or fool us into thinking that they don't care about the sculpture of the past.

Thomas Demand, <u>Tavern 2</u>
(<u>Klause 2</u>), 2006, C-print/
Diasec, 178 x 244 cm

Nor is a photograph necessarily just a photograph any more.
Take the example shown above of a photograph by German artist
Thomas Demand, entitled *Tavern 2* (2006). What appears to be
an exterior view of a pair of windows covered by ivy is, in fact, a
carefully lit and painstakingly crafted scenario made from
thousands of pieces of cut paper, referencing the exterior of a bar
where a brutal murder had taken place in Burbach, Germany. In
other words, what we're looking at is a photograph of a model of
a photograph, and so what is depicted could be described as
either a real, an imagined or a heavily mediated situation, just as
Demand has similarly re-created or reinvented such intriguing
but relatively inaccessible interiors as those of the White House's
Oval Office (*Presidency*, 2008) and the Fukushima Daichi nuclear
reactor (*Control Room*, 2011).

The lifesize paper models built by Demand and his team are
usually destroyed once the photograph has been taken, although
they have occasionally been exhibited as three-dimensional
works in their own right (such as the 50 tonnes of card that went

into making *Grotto* of 2009), blurring the artist's already confused roles as photographer, news reporter and craftsperson with that of sculptor as well. A further complication occurred when Demand multiplied and printed a detail of the ivy in *Tavern 2* as wallpaper, to line the rooms of his 2006 Serpentine Gallery exhibition, thus adding yet another layer to peel away from his staging of the photograph as conceptual-art conundrum.

Aside from his penchant for gruesome or political subject matters, Demand's practice is emblematic of that of many current artists who choose to travel across the boundaries of several different disciplines or work with various media. These artists typically refuse to restrict themselves to one material or method, preferring to give themselves the option of using any media available to them, sometimes seemingly – to dizzying effect – combining them all at once.

Another relatively recent phenomenon – although all of these contemporary strands do have historical precedents of some kind, usually dating at least as far back as the 1960s – is in the field of performance art or theatrical art (sometimes referred to as relational art, but that I will later address as 'Art as Event'), which not only involves other people, perhaps volunteers or paid actors performing in the gallery spaces, but also generally implicates the viewer as a participant in the piece too. The upshot is that art can be anywhere and anything; it could just as well be another person, or a set of simple instructions or even a philosophical gesture, which breaks all the rules we used to think applied to looking at pictures on walls. This diversification presents us with a problem, hopefully one that this book can help to solve.

POST-EVERYTHING

My case for a notional 'declassification' of contemporary art begins with the fact that the discernible movements or neat labels that characterized art production prior to the twenty-first century no longer exist. All the art-historical certainties of Cubism, Surrealism, Dadaism, Constructivism, Minimalism, Abstract Expressionism and so on have either dissipated over time or been disproven as only a partial story of the much more complex waxing and waning of modern avant-gardes. Whether or not those categorizations of the last century were accurate

reflections of the kind of art that was being produced and discussed at the time, they nevertheless provide us with flashpoints and markers to better picture the grander scheme of the ebb and flow of twentieth-century avant-gardes, a historical period that is now broadly known as Modernism. Now that it's all over, we are left in the wake of Postmodernism, a non-movement born of a general dissatisfaction with – and the gradual dissolution of – those definable eras. The global map of artistic diasporae continues to fracture as well, moving contemporary art production ever further away from the traditional, god-given cultural centres of New York, Paris, London, Berlin and Moscow.

What do we make of this soupy dustbin of history and culture in which we find ourselves? And with so few grip-holds on reality, what might constitute the most relevant or important art objects of the moment? And how do we spot them? With little time or distance to provide perspective and help us decode or evaluate the art of the last decade or so, we find ourselves ill-equipped to understand either the ever-growing sledgehammer-subtle sculptures we find shooting up into the skies around us or the slightest of conceptual sleights-of-hand that can be found tucked away unassumingly in a corner of a gallery.

There can and should be only the simplest of responses to any confrontational or vexatious work of art, which is why this book provides a straightforward set of tools to deal with almost any form of art currently being produced, no matter how alienating or complex it might first appear. The genesis of this approach is John Berger's seminal text, *Ways of Seeing* of 1972, in which the author not only advocates the hard-won clarity that comes with really looking at and analysing works of art, but he also attempts to demystify such objects (mainly Old Master paintings) and separate them from any art-historical importance.

The first tool to help you tackle the jungle of contemporary art is to approach each piece as if it were your first experience with that format, be it a painting, a sculpture or some unidentifiable type of multimedia installation. Only then can you look at contemporary art with contemporary eyes, strip away some of the outer leaves and enter the undergrowth to find out what lurks within. Call it a way of looking afresh or, as I do, the *tabula rasa* approach.

TABU
RASA

The best foundation for any fresh consideration of contemporary art is to start from zero and wipe the slate clean, no matter how many bad encounters you might have had before. Think of your mind's eye as a white canvas, a blank page or an empty gallery, and then slowly let the work fill in that space. In Latin this is known as the *tabula rasa* – the unblemished tablet or blank slate – and it's from that word '*tabula*' that the following mnemonic, or memory-jogging acronym, derives. If you're wondering why I'm using a Latin word to try and demystify contemporary art, at least be thankful I haven't littered the text with this subject's many meaningless rejoinders such as 'dialectics' or 'paradigm'. And no one ever said understanding this stuff was going to be easy, so just remember TABULA:

L A

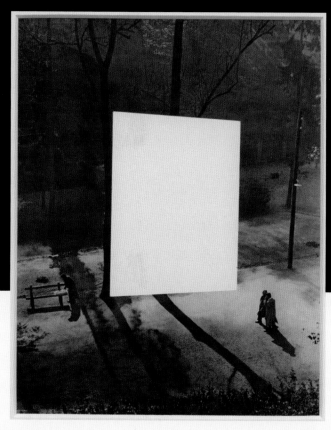

John Stezaker,
Tabula Rasa I,
1978–79, collage,
27 x 21.5 cm

T̲ A B U L A

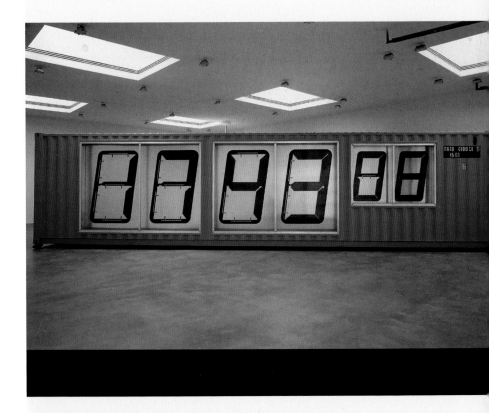

T STANDS FOR TIME. This is the five-breath rule and involves simply standing still for a minute or two to take stock: I'm using five deep inhalations and exhalations as a guide. Too often we judge a book by its cover, dismissing a contemporary work of art as soon as we see it: 'It's a boring video', or 'There's too much text to read', or 'It's too abstract, so I couldn't be bothered', go the usual excuses. I'm not suggesting you punish yourself for hours on end by looking at every piece you encounter in depth, only that you should give everything a little time, a few minutes of calm contemplation, before you move on to the next in our box of tools, which will hopefully help you unpick a work's possible meaning.

TABULA

Left: Darren Almond,
<u>Meantime</u>, 2000. Steel
sea container, aluminium,
polycarbonate,
computerized electronic
control system and
components, 114 x 1219.1
x 243.8 cm

Wolfgang Tillmans, <u>Roy</u>,
2009, photograph, 40.6 x
30.5 cm

A IS FOR ASSOCIATION. This is the most important poser of
all: can I relate to it? The very least that a contemporary-art
experience should provoke is some personal resonance, a gut
reaction, perhaps even a genuine connection. There may be a
purely visual attraction at first or something stronger like a
resemblance or remembrance, but this 'hook' is what we're
looking for and what this book is ultimately structured around.
Each of the following chapters suggests a different way in to a
work of art, whether through its humour, its scale, its message, its
power to shock or its meditative qualities. These hooks are my
own inventions, rather than art-historically accepted norms or
museum-ready categories for what you're seeing. After all, your
relationship with a work of art, however superficial, is more
important to your own understanding of the work than any
prescribed meaning that the artist was striving for, because, if it's
got you interested, then you can move on to the next stage in the
search for significance and sustenance.

TABULA

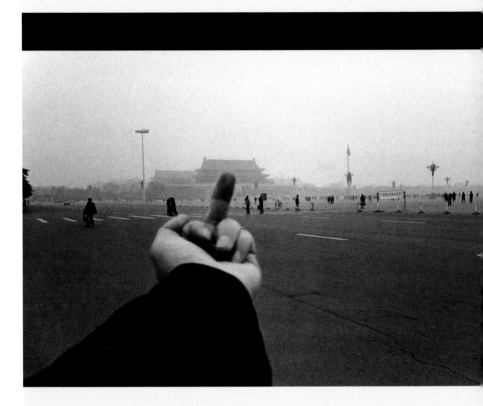

B STANDS FOR BACKGROUND. Much contemporary art comes with a backdrop or story based on the artist's interests or research, just as a religious or mythological painting comes with a readable narrative. Often the title will give you a clue as to the intention; equally there might be an accompanying wall label or press release nearby. Sometimes simply knowing which country the artist is from – China, in the case of this image – will give you all the context you need; on other occasions, seeing more than one work by that artist will similarly reveal something of their intent. This may sound like you need to be well versed in contemporary practice or theory to understand where each artist gets his or her influences from, but this is not about playing hunt-the-art-historical-reference. Again, the following chapters will provide enough thematic food for thought when confronted with a puzzling piece, and there's no sense that you need to be an expert or have a PhD to appreciate a work of art that has been made within the last ten years or so. Besides, who has time for an art-history lesson?

TAB**U**LA

Left: Ai Weiwei, <u>Study of Perspective – Tiananmen Square</u>, 1995–2003

Claire Fontaine, <u>La Société du Spectacle Brickbat</u>, 2006, brick and inkjet print on archival paper, c.100 x 50 x 33 mm

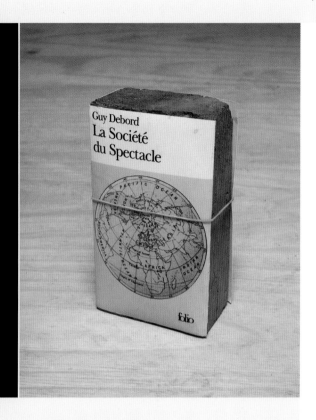

U IS FOR UNDERSTAND. By now you should be getting the message. You've looked, felt for any signs of life or possible love between you and the work, and maybe you've even tried to find out a bit more about the object or the maker. As all this sinks in, some realizations should occur. Perhaps the artist is playing with your perceptions by changing the scale or the siting of an object, or your surroundings have also been altered by the work's presence, either forcefully or imperceptibly; or maybe you've learnt about a historical event or been lured into an unexpected political stance through the artist's vision. Sometimes the road to understanding is only one step away, sometimes it's winding, circuitous and seemingly non-negotiable. If you haven't got there yet, don't fret, as there is still at least one more option...

TABU̲LA

Elad Lassry, <u>Man 071,</u>
2007, C-print, painted
frame, 14.5 x 11.5 x 1.5 cm

Right: Barbara Kruger,
<u>Untitled (Belief + Doubt =
Sanity),</u> 2008, screenprint
on vinyl, 177.6 x 203.4 cm

<u>L</u> IS, PREDICTABLY, FOR LOOK AGAIN. This literally means
you should take that second look, to try and force a double take
or a realignment with the work that enables you to spot the detail
you may have missed before. Even the most facile work of
contemporary art can be enriched through prolonged
engagement; maybe its irony or use of materials becomes
poignant instead of crass and grating, as you originally thought.
Conversely, sometimes the background to a work can throw you
off the scent and ruin your initial response, which is often the
truest and most reliable reaction (whether negative or positive).
This time around, at least you can be sure that you weren't fooled
or being foolish yourself when your head was first turned.

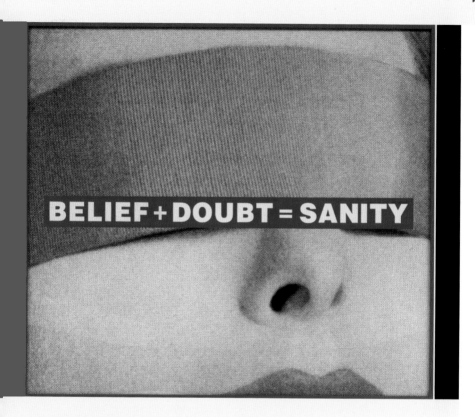

<u>**A IS FOR ASSESSMENT.**</u> Hopefully you haven't jumped to any
hasty conclusions and have instead followed the few steps
through the *tabula rasa* process from wiping the brain-slate
clean, to coming towards some kind of understanding and maybe
even appreciation. Assessing whether a work of art is good or
not, however, is purely subjective, whatever an art critic like me
may say about the quality, consistency, endeavour, originality and
bravery required to stand out from the masses of moribund
modern art. I can't predict someone else's tastes, I can only
espouse and argue on behalf of my own predilections. That's why
outright evaluation is not something this book enters into –
rather, it's the journey from first sight to second look that will cue
resounding applause or else prompt a quick escape.

This *tabula rasa* method of looking at an art object or thinking about an encounter, which I will return to as an analytical device in each chapter, may well be of benefit, or may already subconsciously precede every value judgment or aesthetic decision we make, whether that is buying curtains or looking at a sunset. The next step is to try to understand the milieu or spirit in which each work has been made, given that we can no longer count on any movements or artistic materials to help with an explanation. The following chapters, then, are a series of individual tools to aid with possible readings of works that may not give up their meanings simply by being stared down. Does the artist want to shock or disturb you? (If so, turn to the chapter on 'Art as Confrontation'.) Does it remind you of a cartoon, a Hollywood movie or an internet viral? (Then you need the section on 'Art as Entertainment'.) Does the work make you laugh or smile, and is that even a valid response? (It is, although those who frown upon such interpretations won't enjoy the chapter on 'Art as Joke'.) Finally, after riding the rip-roaring wave of contemporary art's most spectacular offerings, I will offer a way of slowing down your appreciation of contemporary art ('Art as Meditation') and even translating those ways of looking to apply to any form of art.

DON'T SPEAK ART-SPEAK

I also hope to combat the obfuscatory tendencies found in the industries surrounding the production of contemporary art. These are endemic in the gallery system, the museum world and the publishing houses of art books and journals, as well as among many other art-world professionals, from curators to critics like myself. Too often, these gatekeepers stand in the way of the understanding of a work of art by using a morass of theoretical jargon and pseudo-philosophical art-speak. This kind of clever-clever writing about art does very little to bolster or boost an artist's cause, other than perpetuating more reams of similarly hard-to-fathom 'discourse'.

Many galleries and institutions are guilty of this verbose overcompensation in their insistence on using the most opaque language in handouts. My colleagues, from whom I am by no means excluded, are also at fault for providing such texts in the first place, although I would in no way belittle those academics

and art theorists who can further develop the field of art history for future generations of students. Yet between the extremes of good, bad and nonsensical writings on art, there remains an enormous interpretative gap between those texts that are laced with gobbledygook and those that provide either serious scholarship or, on the rarest of occasions, some sensible commentary for the average, enthusiastic but not necessarily art-trained viewer, for whom this book is intended. This is why you will find no philosophical quotations or art-historical references from any of the other, far more esteemed critics or writers who have gone before me in attempting to elucidate contemporary art, although a selection of recommendations is provided at the end for those wishing to pursue further, more in-depth reading.

TRUST NO ONE BUT YOURSELF

Being a sceptic and a critic of contemporary art myself, as well as a champion of it, I don't wish to suggest that simply seeing is believing – just because an object exists in an art context doesn't mean it should be labelled as contemporary art without prior cross-examination. That would be too easy. However, it does help to be something of a believer in the first place, and hopefully this book can help with those who have some faith but remain unconvinced. Those harbouring more antagonistic attitudes towards contemporary art only reinforce a blinkered laziness in the face of anything remotely challenging or new.

Another preconception that I would hope to dispel about contemporary art, aside from its reputation for being a cerebrally superior and overcomplicated form of culture, is that it is an introverted club for insiders, open only to those who either know how the art world functions and who its various players are, or who are wealthy enough to belong as collectors or patrons. There is no secret-society induction or credit check involved in visiting contemporary art venues. Indeed, the number of visitors to giant museums such as Tate Modern in London and the Museum of Modern Art in New York keeps rising every year, while institutions without strong programmes of contemporary art, such as the British Museum and Metropolitan Museum of Art in those same cities, are expanding their commitments to living artists in order to compete. London's National Gallery has hosted

successful residencies for artists such as Michael Landy, whose irreverent installation, *Saints Alive* (2013), reconfigured scenes from early Renaissance depictions of sainthood as raucous, hysterically dangling assemblages of body parts, metal cogs and other found objects.

Of course, not every provincial museum or art foundation outside the major art capitals has great modern-art holdings. Consequently, these smaller *Kunsthalles* and regional spaces are being filled with newer art – for no other reason than that there is far more of it available and more being made all the time. Nowadays the size and ambition of commercial art galleries, not to mention their often close relationships with living artists, mean that they too are becoming increasingly popular venues for discovering new work. Contemporary art is steadily becoming the *lingua franca* of international culture, which makes it all the more surprising that so few in the art industry outside of museum education departments are spending any time to help viewers unpick or translate these invading swarms of creation with their foreign languages and unfamiliar forms.

While John Berger presciently argued in *Ways of Seeing* that 'The days of pilgrimage are over, it is the image of the painting which travels now', I still believe that encountering a work of art in the flesh is paramount to its understanding. The representation or reproduction of a work of art is just so: a replica, a stand-in and ultimately a poor cousin. But Berger is right in that I cannot expect everyone to have access to exactly the same works of art that I am giving as examples of how and what to look for in any such first-hand encounter, a few of which follow every chapter, including two such 'Spotlight' features after this introduction. Each piece in this global spread of current practice is meant to exemplify one particular strand of art, the hope being that my choice of video art, say, can help viewers appreciate any similar work found in a darkened gallery space or on the internet, regardless of its length, subject matter or situation.

Your own personal experiences and mythologies will inevitably colour any encounter with a work of art, and these are to be trusted just as implicitly as your *tabula rasa* tools. After all, no man is an island and the work's context can come from within as easily as it can be found in the following pages.

Michael Landy, <u>Saints Alive</u> exhibition, 2013, National Gallery, London

CHRISTIAN MARCLAY
THE CLOCK, *2010*

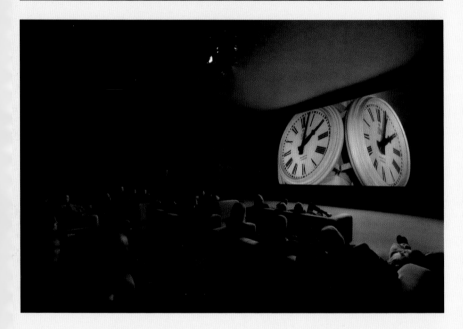

The seconds and minutes tick by in a darkened room. How long do I stay? Christian Marclay's epic, twenty-four-hour cinematic collage gathers countless movie clips that feature wristwatches, alarm clocks, airport or train-station boards, digital and analogue timepieces (even sundials) and anything else pertaining to time that has been captured on film, all of which are painstakingly edited together into one whole day of clock-watching. This relatively recent work has already been widely discussed in terms of its service to film history and the depiction of time itself, functioning as it does as an accurate if unwieldy clock. However, little has been said about the place of *The Clock* as a

piece of video art, or why we might want to stick with any such lengthy, looping art film for more than the usual, dismissive two or three minutes, max.

Let me set the scene, or scenes. Marclay and a team of researchers collated thousands of film excerpts corresponding to precise moments on the clock (the artist is half-Swiss, after all), often with recurring activities or themes linking the footage – so 7am is when most people seem to wake up (Michael J. Fox in *Back to the Future*; Hilary Swank in *Boys Don't Cry*) and midday is traditionally when a cowboy comes out of the saloon (Gary Cooper in *High Noon*). Midnight, or rather the seconds leading up

'ITS IMPOSSIBILITY AS AN ACT OF WATCHING IS INTRINSIC TO ITS BREADTH AND MEANING AS A WORK OF ART'

to it, provide the most climactic moments, when all the church bells bong, the clock tower of Big Ben is symbolically blown up in *V for Vendetta* and Orson Welles plunges to his death off a similar structure in *The Stranger*. The minutes just after each hour are also full of incident, with people running late, bemoaning a missed appointment or looking relieved that the bomb they've just defused hasn't gone off.

Astoundingly, every minute past and every minute to every hour of the day seem catered for in Marclay's movie marathon. Even allowing for a few obscure sources, such as a couple of Chinese-language films and some art-house classics of world cinema, including Wong Kar-wai's *In the Mood for Love*, Akira Kurosawa's *Ikiru* and Ingmar Bergman's *Seventh Seal*, most of the snippets are recognizably mainstream or Hollywood fare. This constant flow of samples (a technique the artist has used in many other works, involving both moving images and soundtracks) keeps us glued to the screen and guessing as to what is coming next. It also functions as an exemplar of the next chapter's tool for reading art as entertainment, because it continuously asks us the question: Where have I seen this before?

In spite of being displayed in a hushed, darkened environment, which is so often an immediate turn-off for museum-goers, *The Clock* is both addictive and stirring, but it's almost physically impossible to watch the whole thing straight through, from start to end (although one Canadian journalist did, more or less). I find that individual sections

are also hard to recall, even after multiple visits (I have sat with it half a dozen times in various locations, mainly in London and Venice, since when it has been bought by museums around the world). Its impossibility as an act of watching is intrinsic to its breadth and to its meaning as a work of art, in the same way that Douglas Gordon's 1993 day-long video homage to cinema, *24-Hour Psycho* – an interminably slowed-down version of the 1960 Hitchcock slasher flick – was purposefully uncontainable as an experience.

This kind of video work presents a challenge to the viewer: how do you make sense of something you can't wholly grasp? This is one of the ways that the conceptual dimension of art diverges from our usually logical habits of watching films, plays or concerts. It presents us with a simple idea – a film made up of films that lasts a whole day – which actually complicates reality by foregrounding our time spent watching it and what we are doing or not doing with those hours and minutes. Viewed like this, *The Clock* could be seen to be counting down the precious seconds we have left on Earth; it's an existential place to be. That is why being there is different from knowing about the intention: time takes over and the art seeps in. This is also why this book is here, to help merge the conceptual side of thinking with the practical side of looking and then to know how to deal with it – how to work it out for yourself and so make the best of it. Look, think, look again, because there's not much time left.

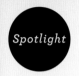

MARTIN CREED

WORK NO. 227
THE LIGHTS
GOING ON AND OFF, *2000*

An empty white space is briefly, brightly lit, before being plunged into semi-darkness. Five seconds later and the lights come back on again with a barely audible click. Repeat *ad infinitum*. There's nothing to see here, no matter how hard I stare at the switches on the wall, urging them to move. I have only other bemused viewers for company as we all do that awkward, polite dance around each other, not knowing where to look, what to do or how to respond.

This simple conceptual piece by Scottish artist Martin Creed quickly became a standard-bearer for all that was wrong with contemporary art, its intangible construction causing substantial ructions and incandescent rage in the press, not to mention a bout of egg-throwing and an inevitable Turner Prize win for the artist in 2001. Of course, Creed was not the first naughty nihilist to attempt to make art with the fewest possible means – Yves Klein exhibited an empty gallery as *The Void* in 1958 and Land art exponent Robert Smithson stated that 'Installations should empty rooms, not fill them' – yet no other work of art rates as anywhere near as frustrating, querulous and divisive as *The Lights Going On and Off*.

What do we have here, then? A malfunctioning electrical circuitboard or the very story of civilization itself, from the Dark Ages to the dawn of the Enlightenment? Both readings are too didactic and miss the many shades of grey within Creed's opposing states of illumination, especially when you consider the free-form and playful nature of the rest of his practice, which features everything from the humour and banality of someone being sick to the futile measurement of time and space with balloons, balls of paper, musical notes or nails.

> **'IT'S A VISUAL ANALOGY
> FOR THE SPARK OF CREATIVITY,
> THE LIGHT BULB THAT GOES
> ON IN YOUR HEAD'**

Although first executed in 1995 as *30 Seconds with the Lights Off*, accompanied by drumming and loud guitars that stopped when the lights went up, in its later form Creed's radically simple gesture is further stripped down to only the most basic requisite for any work of art: that it be an idea. It's a visual analogy for the spark of creativity, the light bulb that goes on in your head. Rather than dwelling on the negative side – the darkness, the yin, the evil – Creed's glass-half-full piece offers a brief moment of possibility for the act of creation to take place. To use the life-affirming refrain from a neon text Creed made the year before: 'Everything is going to be alright'.

When art theorists began tackling the awkward boxes and steel slabs of 1970s Minimalism in America, one of the more disparaging terms used to describe the experience they elicited was that of 'theatricality', meaning that the three-dimensional pieces were somehow stagey,

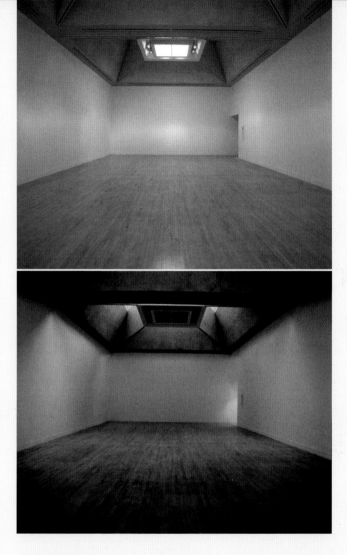

confrontational and forcibly interactive or even interrogative, when compared with, say, a passive painting on a wall. *The Lights Going On and Off* is much more sprightly and funnier than most portentous lumps of Minimalist art, even though it could be considered among the maximum expressions of Minimalism. It's certainly a bit of theatre, turning the exhibition space into a stage and the viewers into unwitting performers. But the question remains: Do you play along and applaud at the end?

This is a work that can exist in the mind both as an affront to sensible, mainstream taste, or as a sly nod to those in on the joke, enacting contemporary art's ultimate game of 'now you get me, now you don't'. Perhaps Creed understands that if no strong, gut reaction – good or bad – is provoked in the viewer, then the work won't be any good. You can choose to ignore it, but the lights are still there, flashing and winking at you. You cannot, however, fail to understand its unerring logic or its universal, timeless challenge to the simple act of looking. Blink (for five seconds) and you'll miss it. But life's like that, isn't it?

ART AS ENTERTAINMENT

'GREAT LORDS
HAVE THEIR
PLEASURE, BUT
THE PEOPLE
HAVE FUN.'

MONTESQUIEU, THOUGHTS
AND FRAGMENTS, 1901

'Wooohooo!' 'Yippeeeee!' These are not the sorts of exhortations generally heard in a museum or gallery, where you are more likely to encounter a low-level hubbub of whispered interpretation or chin-stroking approval.

It's 2006 and I am on the top gallery level of Tate Modern in London at a press conference, watching its usually august director, Nicholas Serota, fold himself up into a narrow chute and plummet down a spiralling metal funnel to the ground floor of the Turbine Hall. He doesn't holler in delight or fear, but other thrill-seekers behind him ditch all decorum for their noisy, high-speed rides through empty space, while I contemplate my place in the shrinking queue. I promptly turn and leave the line.

Being a critic means having to submit yourself to all sorts of ignominious pursuits in the name of art: sniffing hanging sacks of pot-pourri in a giant installation made from stretchy nylon, putting on body-enhancing clothing or disorienting masks, still musty from the 1960s, and even lying in a claustrophobic spherical pod to be bombarded with kaleidoscopic strobe-lights and pulsating noises. There's nothing wrong with a little interaction; indeed, later chapters in this book on 'Art as Event' and 'Art as Meditation' will discuss the energizing qualities of

Carsten Höller, Test Site, 2006,
installation, Tate Modern,
London

works that surround, involve or soothe you. No, what I object to is being forced to hurl my frame around some assault course of an exhibition or, worse, to *enjoy myself*, when all my critical faculties are screaming that I should be taking a measured position on whatever it is I am reviewing. All that, and I hate heights.

But, taking my own advice on how to read vexing or potentially dangerous works of art, I clear my mind and invoke my *tabula rasa* set of rules. T stands for Time, something these slides, by Belgian-born artist Carsten Höller, don't seem to require a lot of – in fact, a few seconds is all it takes to deposit each entrant from top to bottom. But, instead of heading down the long, dark tunnel, I spend a few minutes to descend the stairs through the various levels of Tate Modern, finding five sets of stainless-steel slides in total, all combining and intertwining with the building to create a pleasing sculptural network of pipes.

The A for Association is easy: everyone can relate to the childhood thrill associated with playgrounds and their promise of unadulterated delight. Subconsciously, I'm sure that before I chickened out of the queue at the top, I had relived a moment of vertigo anxiety that went straight back to an exceptionally tall and steep slide that I eventually conquered as a boy – which briefly comes back to me as a heartening memory. Such personal, seemingly inconsequential anecdotes can still be as valid as any intellectual or aesthetic responses and can colour or enhance the enjoyment of a work of art accordingly. In this case, any negative associations I had with rollercoasters and the like were tempered by the possibility of conquering my fear of heights – the slides actually offering me a chance at some kind of therapeutic, perhaps even cathartic redemption.

Now for the B, the Background to Höller's installation and its title, *Test Site*. Trained as an entomologist in Germany, with a doctorate on how plants protect themselves from aphid attacks, he soon gained notoriety as an artist for his mind-bending situations, perception-altering installations and, of course, for his slides – once building one for the fashion designer and art collector Miuccia Prada in Milan so that she could zoom through her offices down to her car outside. Even before the Tate commission, Höller was producing such fun-house installations as *Y* (2003), in which a swirling vortex of bulbs lit up as you walked through a

Carsten Höller, Y, 2003.
960 lightbulbs,
aluminium, wood, cables,
electronic circuitry, light
signs, mirrors, approx.
1,300 x 850 x 320 cm

tunnel, and *Amusement Park* (2006), which featured abnormally slow bumper cars and carousels whirring away ominously. Since then, he has gathered many of these elements into one show, called *Experience* (2011), which led New Yorkers on a magical mystery tour through the New Museum via slides, hallucinogenic light shows, an offer of a 'love drug' for ingestion and even a session in a flotation tank filled with salted water heated to the temperature of human skin. If, however, you are not pre-armed with this knowledge of Höller's back catalogue, then the history and scope of this and other large-scale commissions in the Turbine Hall could be quickly gleaned from Tate Modern's own labels and signage. And, while the pseudo-scientific nature of Höller's project may not be immediately obvious, it is one of many immersive installations that doesn't need much in the way of context – only a strong stomach is required.

In order to attempt the next letter in the sequence, U, and gain at least a rudimentary Understanding of Höller's strange yet enjoyable art, it's time for me to take the plunge. Having read and listened to his descriptions of the slides as being like 'a barely controlled fall', or how vertigo imposes 'a voluptuous panic upon an otherwise lucid mind', it's hard not to feel like a test subject myself, doing the artist's behavioural bidding, like a caged rat in some sinister sociological laboratory. But this may simply be my aversion to being told what to think or how to respond by these pulse-quickening rides or pupil-dilating tricks.

These nagging prejudices against Höller's work mean I should quickly invoke the L and Look Again – or, in my case, stop putting it off and get in one of the infernal slides. I barely have time to yell *'tabula rasa'* as I bucket down one of the silvery flumes and puddle onto the Turbine Hall floor alongside my fellow tube travellers.

Finally comes A for Assessment. My snap judgment as a guinea pig unceremoniously spat out of Höller's art experiment is one of sheer, adrenaline-fuelled joy. Despite those initial fears (I braved all but the uppermost slide) and misgivings about his cod-scientific motives, and with the added benefit of hindsight, there's no doubt that *Test Site* was hugely entertaining, in a physical, visceral and nerve-jangling way that had little to do with the usual museum-going experience, which is so often

confined to merely visual and cerebral enjoyment. High-cultural snobbery aside, is there actually anything wrong with appreciating art, first and foremost, on this most base, primal, gut-churning level?

WE WILL ROCK YOU

As well as the more familiar sight of paintings or drawings on walls, exhibitions nowadays might well include anything from a merry-go-round or a giant inflatable to a set of animatronic heads or a talking cartoon character. The populist, circus atmosphere created by such works means that contemporary art can be as crowd-pleasing an experience as a major sporting occasion or a rock concert. Indeed, art is increasingly being packaged in this way, with galleries looking to rival visitor attractions such as football matches and stadium gigs for audience numbers.

To gather such significant human traffic, the work on display has to compete on the same intellectual playing field and likewise be aimed squarely at mass appeal. This means it has to have impact, energy, a fun factor, and high levels of interactivity and accessibility, if not a grand scale (this phenomenon will be dealt with separately in a later chapter on 'Art as Spectacle'). It shouldn't be too sedate, nor should it alienate or disturb to be truly popular (even if the next chapter on 'Art as Confrontation' proves how energizing this quality can be in contemporary art). Rather, it should titillate and stimulate. Come on in, enjoy the ride!

Venues have to be big and brazen enough to show off this crowd-friendly stuff. Every town or city worth its name has built itself a new museum of modern art, or else a contemporary-art institute or foundation, in the same way that not so long ago it might have built a megamall or a multiplex cinema to placate its citizens. We don't visit our cultural institutions to think deeply any more, rather we go to get a 'dose' of culture – a quick hit of something that may be only two shades more challenging than what we see on TV.

There might be no real need to find any deep meaning in the realm of entertainment art, especially if you're too busy enjoying yourself to ponder questions of space, time or collective experience. But contemporary artists are under pressure to

Paul Pfeiffer, Four
Horsemen of the
Apocalypse #17, 2004

maintain their *gravitas* and hide any suggestions of frivolity or pleasure beneath layers of complex theory about social behaviour or bodily physicality – instead of describing their work as overtly addressing the world of sport, for example, as in the case of Hawaii-born Paul Pfeiffer's majestic stills and videos of basketball players and boxers that have been removed from their arena. Such theoretical diversionary tactics might be necessary to keep up the artistic pretence of protracted forethought and so save face when the practitioner in question is asked to defend the costs of making something big or expensive, but only make our job of engaging with and appreciating the work that much harder.

Take the internationally renowned conceptual artist Daniel Buren, famed for his use of candy stripes that alternate between white and one other colour (originally they were green). The Frenchman started out on this career path in the mid-1960s, with the aim of trying to achieve a 'degree zero of painting' (his own conceptual wiping of the slate), before departing from his radically pared-down manifesto to go on and infect every imaginable surface with his now-familiar stripy patterns, colonizing not only gallery walls, but public spaces in Paris and beyond. Buren has covered walkways, pergolas, billboards and awnings, and was recently invited to fill the Grand Palais in the French capital for the fifth in its biennial series of *Monumenta* installations, one of the largest commissions of its kind in the world, where he placed brightly hued, spherical Plexiglas shelters for viewers to walk through, with his signature stripes decorating the glass and steel structure above. Whatever conceptual claims were made on behalf of this giant work, *Excentrique(s)* (2012) – such as, that it 'reveal[s] the space's hidden dimensions, invisible potential, past and present' – there was no doubting its sheer entertainment value, as an enjoyable, light-filled place to take a stroll through, pose in front of, or frolic beneath. Buren may or may not protest at such a simplistic reading, but on my visit his *Excentrique(s)* initially transmitted little more to me than 'Here we are, come and play'. Again, admitting a work of art is fun may not be a damning criticism, so much as an honest appraisal. Trust your instincts on these occasions because this kind of unfettered interpretation can be as valuable as all the long-winded philosophical explanation you care to throw at it. Sometimes it's harder to find the right words than just to submit to a work of art's spirit of joyful, carefree abandon. In these cases,

Daniel Buren,
Excentrique(s), 2012,
installation, Monumenta,
Grand Palais, Paris

don't read anything into the experience or bemoan your own lack of intellectual rigour: just enjoy it as you would a trip to the amusement arcade, cinema, shopping mall or themepark. And don't forget to smile for the commemorative picture. Once you've started to enjoy yourself, maybe some further meaning will reveal itself – depth and enjoyment need not be mutually exclusive. In my case, Buren's colourful funhouse became an exploration of architectural possibility and a performative, even therapeutic place to promenade.

Omer Fast, 5,000 Feet Is the Best, 2011, still

POP SENSATIONS

One of the most commercially successful artists of the past two decades is Takashi Murakami, a Japanese artist whose work references such niche subcultures as *manga* strips, erotic comicbooks and cutesy or *kawaii* cartoon characters – hitherto exclusively the preserve of the young, male Japanese geek or *otaku*. Murakami's art empire straddles New York, Paris, Taipei, Hong Kong and Tokyo and includes the design and manufacture of toys, stickers and T-shirts, as well as high-priced sculptures, paintings and luxury fashion-label crossovers. His feverish 'artrepreneurial' production line rolls on without any hint of irony or satire, seemingly only perpetuating the notion that an artist that goes out of his way to entertain can create only light, frivolous statements that lack any sustenance. Indeed, I never looked twice at the tiny Murakami figurine of a blue mouse on a toadstool (supposedly a self-portrait of the artist) that I got free with some bubblegum once in Miami, until, that is, I saw it exhibited at Tate Modern as part of a set of his *Shokugan* or 'snack toys'.

Yet, if I honour my *tabula rasa* promise to look again at such works, however superficial they may seem, Murakami's factory-style output could also be regarded as making a vital, wider statement about our traditional culture's lack of supremacy over newer forms of mass entertainment consumption – even if this is a message we may not want to hear or think we deserve. Stupid yet simultaneously smart, Murakami's work highlights the complex nature of living in a culture centred around easy gratification and the very same unthinking consumption it mirrors. If that leaves you feeling cheated or empty inside, then perhaps that's the point.

As the traditional division between art and life becomes ever more porous, artists are being commissioned to design everything from playgrounds to car decals, soft drinks and park benches, or anything else that might once have been considered a frivolous distraction from the serious business of making art objects. It should therefore come as no surprise that contemporary artists – who, let us not forget, are no more immune to the pull of the popular-entertainment industries than the rest of us, and no less entitled to earn a living from what they do – might also take an interest in public activities of leisure or indulge their own pastimes or passions to make records, films, websites or even toys as part of their practice.

The German artist Omer Fast, for example, pays homage to Hollywood cinema, computer-gaming culture and even pornographic filmmaking in his work, but more importantly reveals some of the behind-the-scenes secrets or the leaps of faith between fact and fiction involved in those genres or industries. In Fast's talking-head films, such as the four-screen installations of *Casting* (2007), based on the testimonies of a young US soldier recently returned from Iraq, or *Everything That Rises Must Converge* (2013), constructed from interviews with porn stars, it is hard to tell who is acting from a script or simply playing fast and loose with an actual kernel of truth. In *5,000 Feet Is Best* (2011) Fast mixes the accounts of air strikes in Afghanistan performed by a real Predator drone operator with aerial surveillance shots of American suburbs and streets. At one point a typical family – two kids, a soccer mom and dad in their station wagon – is struck by a Hellfire missile (although incredibly they walk away from their

burnt-out vehicle as if in an action movie or shoot-'em-up game), bringing the remote possibility of such far-flung military dangers into sudden, sharp focus.

THAT'S EDUTAINMENT

Much of the work that entertains the eye with candy colours or otherwise grabs our attention like a blockbuster flick can also be relevant and timely by challenging us to question our own deficiencies as often unwilling consumers of highbrow culture. In Good Feelings in Good Times (2003), Slovakian artist Roman Ondák he staged various futile queues outside museums or art fairs, with people paid to stand in line for no reason. Not only did Ondák's mysterious single files of performers prompt curiosity and interaction – why has the line formed, what are they waiting for? – they also suggested some kind of benefit or reward for joining, because, as we all know, it must be something of real cultural worth or entertainment value if there's a queue. Who knows, there might be a slide at the end of it.

The idea that art might be read through the same lens as entertainment also helps us gain a foothold in some otherwise bewildering objects, usually when something familiar, such as a queue, is being appropriated and then radically repackaged by an artist.

Art that entertains need not be lightweight, but its first function is to ensnare us – any educating or indoctrination has to come later. The eminent curator and art historian Robert Storr gave a lecture in London just before he opened his edition of the Venice Biennale in 2007 in which he said: 'Once you have enthralled the public enough to get them through the doors, one of the greatest tasks of museums and curators is disenthralling.' Artists may not be thinking about accessibility when creating their work, but they are aware that without an audience any art will wither, so it is in their interests to make sure that their work is seen by as many people as possible. As the gap between art and entertainment becomes narrower and the relationship between the two gets ever cosier, we have to hope that artists know when to hold their ground and not sell out, when to thrill their audience and when to walk away.

Roman Ondák, Good
Feelings in Good Times,
2003

41

JEREMY DELLER

SACRILEGE, 2012

I am gingerly bouncing up and down on a giant green inflatable at the centre of what looks like Stonehenge, the fabled Neolithic circle of standing stones on Salisbury Plain – only this isn't an ancient corner of southwest England, but the Place des Invalides at the heart of Belle Époque Paris. In truth, I could be anywhere, as Jeremy Deller's subversive, transient public-art project, *Sacrilege*, has just completed a four-month tour of parks and green spaces all over Britain as part of the London 2012 Festival, the cultural programme helping to celebrate the Olympics. It's good, clean fun, but feels more than a hop, a skip and a jump away from serious art.

Of course, as the last chapter showed, attempting to read or understand contemporary art through the prism of its entertainment value is not always to do it a disservice. Deller, whose work often takes the form of a procession, a gig or a gathering of some sort, revels in these very shared experiences that bind us together as people, whether through a sense of community, a love of music or a common political belief system. His most powerful and thought-provoking piece remains *The Battle of Orgreave*, a 2001 re-enactment and filming of the pitched battle that originally occurred between striking miners and riot police in a field outside a small Yorkshire town in 1984. Albeit much more celebratory and child-friendly, his interactive, bouncy playpen version of Stonehenge is a historical re-creation of sorts too. Yet, as its title suggests, *Sacrilege* also carries with it a contradictory

undertow of ironic reverence and an iconoclastic attitude towards our prehistoric past and our supposedly sophisticated present.

> ### 'JUMPING UP AND DOWN ON A FACSIMILE OF AN ANCIENT TEMPLE TO THE STARS FEELS AS SILLY AS IT SOUNDS'

It wasn't so long ago that visitors to the real Stonehenge could clamber over its five thousand-year-old menhirs and dolmens, like the Druids before them. But fears over its erosion in the late 1960s and early '70s led to protective and prohibitive fences, a pedestrian tunnel, a parking lot and a bus terminal blighting the surrounding area. That botched solution was arguably as disrespectful as Deller's latter-day reimagining of the World Heritage Site in inflatable vinyl – perhaps more so, when you consider that *Sacrilege* at least conceptually restores access to the stones and our age-old right to roam. By announcing the travelling structure's movements through a website like stops on a rock band's road trip, complete with tour-date T-shirts and mock-Celtic logo, Deller's bouncy castle is also a comment on how we are often led to consume by mass- marketers or presume that culture is something best appreciated in tour-guided herds.

While jumping up and down on a facsimile of an ancient temple to the stars feels as

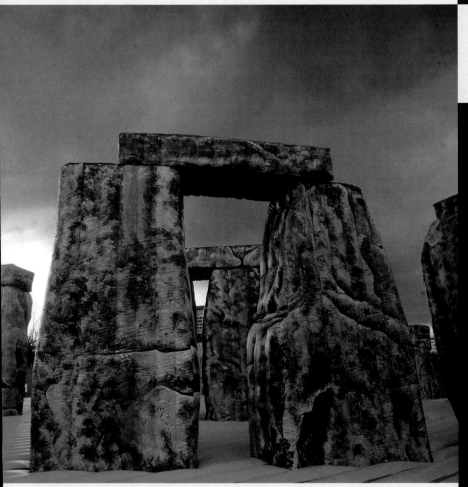

silly as it sounds, it's often only when you hold something up to ridicule that you begin to see what it really is. But the most perverse aspect of *Sacrilege* is its symbolic inversion of the stated mission of most permanent public art: if you build it, people will come. Unlike the ever-larger monuments in steel or bronze that are erected to attract newcomers or tourists to a depressed town or neglected neighbourhood, this monument might be here today but will be deflated, packed up and gone tomorrow.

CORY ARCANGEL

DREI KLAVIERSTÜCKE, OP. 11, *2009*

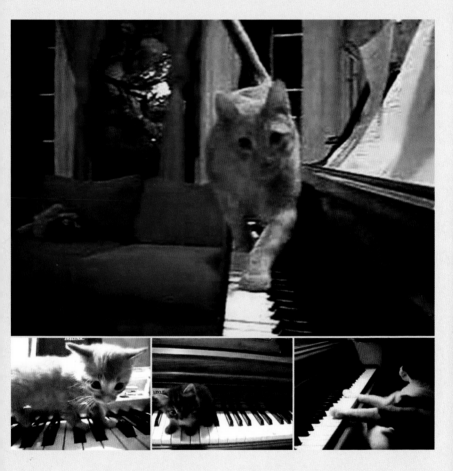

A fluffy cat lies sprawled on a piano, then another steps lightly across a different keyboard. Plink, plonk. Next, an owner helps their cat 'play' a note and a ginger tom prods uncertainly at the ivories. While the internet is full of time-wasting websites devoted to humorous cat clips or cutely captioned kitty photo-galleries, this cut-and-paste collage of YouTube videos is different, because after four minutes you will have watched these felines perform an almost perfect recital of the first piece of atonal music ever composed.

Contemporary music critics in Germany

greeted Arnold Schoenberg's unashamedly modern and dissonant 'Drei Klavierstücke' ('Three Piano Pieces') of 1909 with hoots of derision. A century later in New York, a young multimedia artist and computer-programmer seemingly proves those reviewers right by showing how a bunch of cats randomly hitting piano keys could be capable of composing such avant-garde music all by themselves. In fact, Brooklyn-based Cory Arcangel downloaded around 170 cat videos before diligently re-editing them over a period of six months, precisely matching each cat's audiovisual accident with a note from the three movements of Schoenberg's experimental, fifteen-minute score.

'THESE FELINES PERFORM AN ALMOST PERFECT RECITAL OF THE FIRST PIECE OF ATONAL MUSIC EVER COMPOSED'

Arcangel was trained in classical guitar and musical composition at Oberlin Conservatory of Music in Ohio, before he began turning his hobbyistic trawling of internet 'memes' and inconsequential or obsolete areas of technology into works of art. Describing himself as something closer to a hacker than an artist, the digital wunderkind has previously manipulated old Nintendo game cartridges, reducing the arcade action to nothing but their backgrounds – leaving behind existential, minimal landscapes without any characters, such as *Super Mario Clouds V2K3* (2002) – and rigged sports games on outdated

consoles so that the player loses every time. What might seem like a disappointed, dystopian take on entertainment and technology is often born of a genuine love for his subjects, rather than fear or loathing. So, Arcangel's pair of computers that continually email one another with 'Out of Office' messages for years on end until one crashes (*Permanent Vacation*, 2007), or his blog that aggregates apologetic messages found on other blogs (*Sorry I Haven't Posted*, 2010), should be read as witty observations of the new habits and points of etiquette that inadvertently clog up our virtual lives.

Corralling kittens into playing a complex piece of modern music is partly a clever reclamation of mass culture's role in disseminating difficult, so-called 'high' art (how many more internet cats would it take to play all of Beethoven, I wonder?) as well as an artistic extension of the internet's function as a repository of unlimited, often useless, lowbrow infotainment. By choosing to work in the online arena where anything is possible and everything is available, Arcangel suggests that it might be time to redraw the limits of what and where art can be. Force quit, refresh, restart.

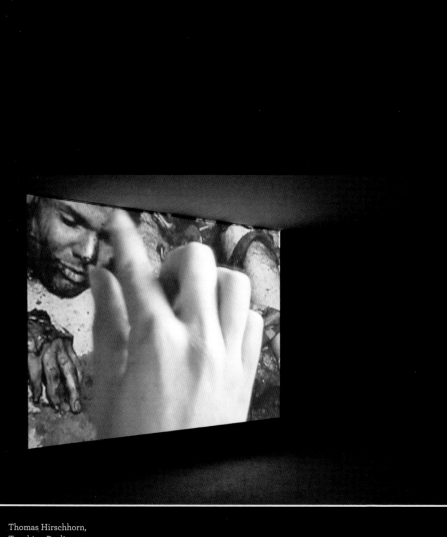

Thomas Hirschhorn,
Touching Reality, 2012,
video

CHAPTER 3:

ART AS CONFRONTATION

'CULTURE SHOCK IS WHAT HAPPENS WHEN A TRAVELLER SUDDENLY FINDS HIMSELF IN A PLACE WHERE "YES" MAY MEAN "NO", WHERE "FIXED PRICE" IS NEGOTIABLE, WHERE TO BE KEPT WAITING IN AN OUTER OFFICE IS NO CAUSE FOR INSULT, WHERE LAUGHTER MAY SIGNIFY ANGER.'

ALVIN TOFFLER, FUTURE SHOCK, 1970

Wandering around the cavernous, cacophonous contemporary art space of the Palais de Tokyo in Paris, filled with giant sculptures and floor after floor of competing works of contemporary art, the last thing I would expect to stop me in my tracks is a tiny flat-screen video on an out-of-the-way wall. But after only a few seconds, I'm rooted to the spot.

The TV monitor I'm glued to shows another screen, that of an iPad or a touch tablet, with a woman's hand scrolling through what can only be described as sickeningly raw photographic images of suicide bombings, charred human remains, bloody decapitations, mutilated faces and detached, misshapen torsos. There is worse besides, as the hand on-screen casually swipes or nimbly pinches at the hideous images to zoom in on some fresh horror, pausing only to focus our attention on a victim or to dwell on bystanders – essentially other witnesses or voyeurs like us – who might be wielding a cameraphone or a digital camcorder to capture the terrifying scenes for themselves.

The accompanying label tells me that this video is called *Touching Reality* and was made by the Swiss artist Thomas Hirschhorn in 2012. Making sure that my young son hasn't seen any of it and has skipped off elsewhere, I am unaccountably unable to take my

eyes off the short five-minute loop. It's repulsive – yet compulsive viewing. Like a car-crash rubbernecker, I stand gawping at the succession of grim, grainy stills – but not for too long. Following my own *tabula rasa* principle seems initially pointless, as I don't need (or can't stand to spend) very much Time to appreciate this work. There's no more immediate Association I can make to these images either, aside from knowing that all my limbs are still attached to my frame – that I haven't been scalped, shot, dismembered or blown apart. Although I do encounter this sort of subject matter regularly on my television or computer screen, I can't say that I truly take the time to empathize or associate with those poor souls on the other side of the world.

Because of my familiarity with news-agency dispatches from war zones there's no real Background required either, although I have seen this artist use such material before in his better-known sculptural installations. Hirschhorn's giant assemblages, with titles such as *Superficial Engagement* or *Crystal of Resistance*, are often composed of shop mannequins, mirrors and cheap white plastic furniture, wrapped in reams of brown packing tape and aluminium foil, or plastered with newspaper headlines and similarly disturbing photographic information. These immersive, handmade environments tend to have the air of a lair built by a madman or a fanatic waiting for the apocalypse, as was the case with *Cavemanman* (2002), a sort of crazed labyrinthine library, its walls slathered in theoretical texts, porn and band posters. By contrast, this short video is far more rational and, consequently, far more troubling.

What, then, do I Understand better having seen *Touching Reality*? Arguably, nothing much. Beyond the initial stomach-churn caused by viewing such bodily harm, images of this kind are readily available to anyone via the internet or on rolling current-affairs channels, albeit most media outlets heavily edit their newsreels to protect us from such appalling realities. I am, however, beginning to understand that it's my response that is somehow inadequate. Abiding by my own formula, the logical next step is to clear my mind and, unfortunately for me, Look Again.

To some extent the real moment of enlightenment here comes not with my revulsion at the car bombings or acts of terror, but with the realization that I might be somehow immune to such

Thomas Hirschhorn,
<u>Cavemanman</u>, 2002,
wood, cardboard, tape,
aluminum foil, books,
posters, videos of Lascaux
2, dolls, cans, shelves,
fluorescent light fixtures

faraway dispatches from war zones – that death becomes invisible after repeat viewing. We don't trust much of what we see on screens nowadays, thanks to CGI and Hollywood, so why take this any more seriously? The nonchalance of that hand flicking past images reflects our own indifference – if I don't like something, I can just change the channel. But, as much as I'd like to pretend these are just ghosts in the machine rather than real depictions of injury and loss of life, Hirschhorn forces me to be affronted by my own inappropriate reaction with each passing tragedy. Upon reflection, all I can see is a mirror of my own guilt – that's the real gut-wrenching moment and the true horror I'm faced with.

DEAD WRONG

As a genre specializing in shocking, distasteful and sometimes badly made objects, confrontational art can be the hardest to look at or put up with for long periods of time, but is still the most likely to grab your attention. In fact, you shouldn't have a problem spotting confrontational art as it usually comes looking for you, perhaps leaping out from the gallery walls and trying to bite you, at least metaphorically, if not literally. And, like a rabid, barking dog, this antagonistic category of art might initially cause fear and loathing, but is more likely to live in your head as a general unease, given that most museums and galleries are safe, sanitized environments, unlikely to inflict real harm. Confrontational art can also consist of objects simply in your way or disturbing your peace; in these situations it's your relationship with the offending works that creates the electric charge or burst of discomfort, rather than any gruesome or alarming subject matter.

Having said that, on my rounds as an art critic I have found myself in rooms kitted out to look like murder scenes, brothels or a terrorist's stronghold. I have also tiptoed past various spring-loaded man-traps, been threatened with a literal shocking by an electrified fence, risked severe burns at a gallery where I was greeted by a flame leaping from the opposite wall, not to mention coming close to many a nasty fall (some of these were actually the consequence of badly placed works, treacherous pitch-black video rooms or optical illusions meant to scare rather than injure). I've been told not to drink from a fountain supposedly laced with LSD, warned that the tiny globe before me contained a bomb that would explode a hundred years from now and watched an old man skateboarding naked in

Klaus Weber, <u>Fountain
for Public LSD Hall</u>, 2003,
installation top view,
Frieze Art Fair, London

Paul McCarthy, <u>Train,</u>
<u>Mechanical</u>, 2003–09,
steel, platinum silicone,
fibreglass, rope, electrical
and mechanical
components

Gregor Schneider, <u>Bodies in Space</u>, 2002

a sinister film about a fictional neurological condition in which people spontaneously remove their clothes. I've been nose-to-nose with disfigured mannequins and sculptures of Pinocchio with their features replaced by lifelike casts of mutilated genitalia and watched as two porcine effigies of George W. Bush humped each other mechanically over and over. I could go on.

Of course, some artists seem to believe that if their work isn't offensive they aren't doing their job properly. Personally, I can't stomach the pseudo-fascistic and intentionally distasteful performances of German painter Jonathan Meese, who uses Nazi swastikas, salutes and oral rhetoric to proclaim his own 'Dictatorship of Art', however ironic his invented persona might be. I've enjoyed the often unseemly, spooky and uncanny environments of his countryman Gregor Schneider, based on nightmarish versions of his childhood home in Mönchengladbach-Rheydt, but could not envision or condone some of his more crass, outlandish ideas, which have included wanting to exhibit a dying or dead person at one of his shows (perhaps unsurprisingly, he has so far failed to find a willing participant).

Jonathan Meese,
<u>Dictatorship of Art</u>, 2011,
performance/painting
piece

DON'T SHOW OR TELL

It's often assumed that the kind of art that shocks does so purely
for its own gain, to make us gasp or recoil, merely in order to
validate or draw attention to itself. Any such object or work wants
desperately for us to look at it, no matter how much we might not
want to see what it is showing us. These pieces might set us on
edge but should, if they are worthwhile as artistic statements,
also reveal some hitherto-misunderstood part of the human
condition or overlooked internal dread that will give viewers
pause for thought and leave more than just a bad taste in the
mouth. One literal example of this lingering effect of
confrontational art is the ethereal installation work of the
Mexican artist Teresa Margolles, who has used diluted blood
from drug-related murder victims to continuously mop the floors
of her exhibition or filled the gallery's air-conditioning units with
water used to wash dead bodies in mortuaries prior to autopsy. In
these atmosphere-changing pieces by Margolles, the very
intangibility or invisibility of the subject matter can make the

Teresa Margolles, <u>What Else Could We Talk About? Cleaning</u>, 2009

work even more powerful. Not showing us is often more horrific than putting it all out in plain sight.

Jenny Holzer is an artist who spent much of her career in the 1980s and '90s using the genres of advertising, public display and sloganeering to get her message across in the most forceful way possible – emblazoning her aphorisms on billboards or street furniture, for example. But, less than a decade ago, Holzer started a series of 'Redaction Paintings' that reproduce declassified American military documents relating to soldiers or activities from operations during the Second Iraq War and the subsequent occupation of the country. Many of the reports, conversations, lists and reports have names, dates, locations and even hand- and fingerprints blotted out with thick pen, allowing our minds to fill in the blanks alluding to interrogation methods and possible acts of torture. The uncensored excerpts make for chilling enough reading on their own: 'The detainee may also have a hood over his head during transportation and questioning... consider whether the use of these techniques would inflict severe mental pain or suffering.' Contemporary art is often accused of similarly withholding information – of not providing satisfactory explanations or enough supporting evidence to help us grasp the full picture of its creation or meaning – but then this can allow for a more complex, rewarding encounter or experience, one that is far less passive than reading the news or watching didactic documentaries on television. It is often up to the beholder of art to connect the dots or wallow in the same moral or mental quagmire as the artists, who very often don't pretend to have all the answers themselves.

0 4 0 6 - 0 4 -CID025-

**Left Hand
(Palm Rolled)**

CHAPTER 3

b6-4, b7c-4

Signature: b6-4, b7c-4

026604

Record Prints of: b6-4, b7c-4

Date Taken: 23 Nov 04

SSN: b6-4, b7c-4

000137

Taken By: INV b6-1, b7c-1

FOR LAW ENF... ...SENSITIVE ...USE ONLY

DOD-052103

Jenny Holzer, <u>Left Hand
(Palm Rolled)</u>, 2007, oil
on linen, 203.2 x 157.5 cm.
Text: US government
document

George Condo, <u>Dreams & Nightmares of the Queen</u>, 2006, oil on canvas, 80.8 x 40.6 cm

Right: Richard Prince, <u>Pure Thoughts</u>, 2007, 1970 Dodge Challenger

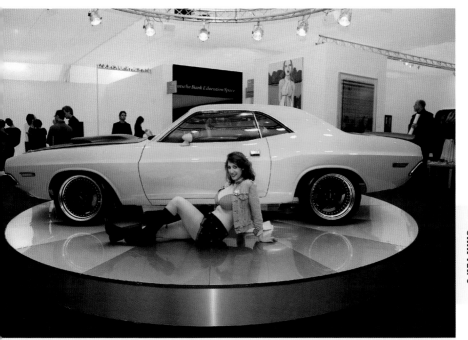

BAD BOYS AND GIRLS

Some artists make work that provokes a reaction simply by being uneasy on the eye or purposefully ugly. George Condo has been painting fearsome, snarling canvases and glaring bug-eyed cartoon characters for so long that they have ceased to be disrespectful to the painters he admires, such as Francisco Goya, Frans Hals or Pablo Picasso, and have become influential in their own right. Other practitioners of schlock-horror or art atrocities are those bad boys who believe themselves to be so badass that they can get away with making work that is so bad it becomes good. Take the New York trio of artists Dash Snow, Dan Colen and Ryan McGinley, whose drug-fuelled rock-star antics and loose morals garnered more column inches than even their bloodied, spit- and shit-filled, semen-stained artworks managed. But attitude and posturing alone weren't enough for one of the three, Dash Snow, who died after an overdose in 2009.

Of course, alongside drugs and rock'n'roll, sex sells in any context and the art world is no exception. Yet we are so used to being bombarded with sexualized imagery that it rarely raises so much as an eyebrow nowadays, let alone any other bodily parts. Ever the provocateur, Richard Prince's decision to exhibit a bright-orange American muscle car (a functioning automobile and a sculpture) at the Frieze Art Fair in 2007 was first and foremost a sardonic play on the trade-show atmosphere of such a

Jeppe Hein, <u>Burning Cube</u>, 2005, metal cube, fire-resistant paint, gas flame, nozzle

brazenly commercial event, but his addition of a buxom brunette sprawled over the bonnet of the 1970 Dodge Challenger provided only a fleeting moment of scandal and the briefest frisson of titillation. Just as we take this imaging and branding of sex for granted – it's become implicit rather than explicit – so we also tend to skim over any deeper resonances that the exposed surface of bared flesh might conceal, but there are still artists who try to get across something meaningful before the short moment of arousal ends.

DANGER: VIEWER BEWARE

If the thrill of a sexually charged encounter with a work of art might not cause outrage anymore, then the threat of actual violence can always take the art of confrontation to the next level. Any experience that endangers or frightens is likely to stay with you, as it has after each time I have been in a room with a piece by the Danish artist Jeppe Hein, responsible for the gallery flame-thrower I mentioned earlier (entitled *Bear the Consequences*, 2003), as well as an innocuous-looking Minimalist sculpture that continuously self-combusts (*Burning Cube*, 2005), not to mention the museum benches that either speed off once you sit on one (*Moving Bench*, 2001) or else engulf the unsuspecting sitter in a cloud of smoke (*Smoking Bench*, 2002). I have donned a silly headset that zapped me with a small electric shock every time I veered out of the confines of his *Invisible Labyrinth* (2005) and got soaked to the skin by Hein's randomly timed vertical fountains of water in *Appearing Rooms* (2004).

I have also stood beneath a Sword of Damocles, a Gulliver-sized steel blade dangling at the centre of a circular nineteenth-century chapel during the 2010 Liverpool Biennial, pondering my mortality, not to mention my likely reaction speed were the thing suddenly to fall. Created by the Belgian artist Kris Martin, whose aforementioned sculptural timebomb, set to explode in 2104, had previously piqued my anxiety, these works and those of Jeppe Hein are ultimately made as challenges to the normally passive viewer – they require us to react to a message that needs conveying, by any means necessary. That message is loud and clear: we should wake up from our perceptive or intellectual slumber and really engage with what is in front of us.

Perhaps the most confrontational art of all is that which simultaneously challenges every notion of respectfulness and every sensible sensibility. Take the French-Algerian artist Adel Abdessemed's installation *Décor* (2011–12), which consists of four identical lifesize sculptures of a crucified Jesus, constructed from perilously sharp razor wire. Presumably meant to shock not only for religious reasons, but on grounds of taste and even on a semantic level as well – the title is an ironic play on two words that don't best describe the work: decoration and decorum – *Décor* seemed to me wholly unsavoury; I almost couldn't stand to look at it (despite not having a Christian bone in my body). It

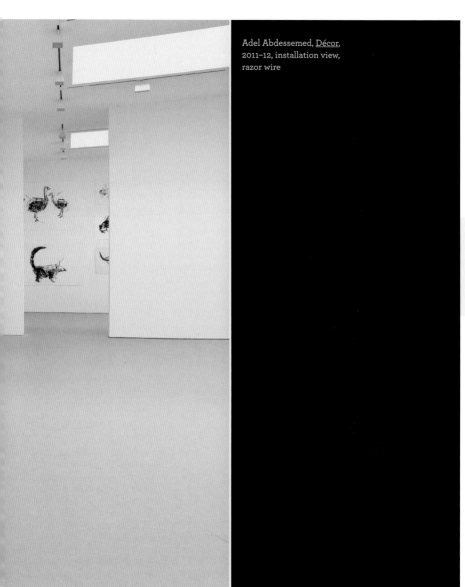

Adel Abdessemed, <u>Décor</u>, 2011–12, installation view, razor wire

seemed so gratuitous and such a clunkingly obvious statement about pain that I couldn't bear it. But then there were four of them. The artist wanted me to Look Again. He'd snagged me in the barbed wire and ensnared me in his trap. After a little Time, Association, Background and Understanding, I realized there was some merit in these grotesque, tortured effigies, with their resemblance to classic paintings and sculptures of the Crucifixion. Abdessemed knows he has gone too far and has crossed the line – repeatedly – but he also knows that his audience is jaded and has seen it all before. Sometimes only a battering ram will do.

SANTIAGO SIERRA

160CM LINE TATTOOED ON FOUR PEOPLE, *2000*

Four Spanish prostitutes are hired by an artist to have a 40cm line tattooed across their backs in exchange for a shot of heroin with a street value of about $67 dollars or 12,000 pesetas. I wasn't there to witness this performed exchange, thankfully, and have only ever seen this difficult work in documentation – one of the black-and-white photographs in particular has always haunted me, as it shows the rather haggard profile of a woman wincing as she waits her turn with the first (tattooist's) needle. The Madrid-born sculptor, activist and political firebrand Santiago Sierra has become well known for such acts of 'artsploitation' – essentially the payment of people for their time or efforts in the name of his art. This has variously involved remunerating Chechen refugees to hide in boxes, a homeless person to sit in a ditch for four hours a day, two Cuban men to masturbate for the camera and a group of five workers to hold up a gallery wall at a 60-degree incline for the duration of an exhibition.

I was, however, unfortunate enough to be present in the room when Sierra paid various war veterans to stand facing the opposite corner of the gallery to me. I watched the slowly shifting back of a man in uniform, who had perhaps served in Iraq or Afghanistan, as he was ritually humiliated and shamed for the sake of the audience. I was once denied entry to one of Sierra's first London shows in 2002 (some of his more offensive projects have been cancelled or censored), when his *Space Closed by Corrugated Metal* thoroughly

confused and infuriated many of those who'd turned up for the opening only to find the gallery firmly shuttered, as were the visitors to the Spanish Pavilion at the 2003 Venice Biennale who were greeted by a brick wall blocking the entrance. As I was born in Spain, I was one of the few granted special access to the pavilion after showing my passport. As it turned out, there was nothing to see but the other side of the wall.

'A WOMAN WINCES AS SHE WAITS HER TURN WITH THE NEEDLE'

For all the controversy and criticism that Sierra has personally incurred for re-creating the economic conditions of cramped and unfair working environments for minimum-wagers, there has been at least as much debate and as many words expended as a result of his highlighting of the issues of the illegal movement or payment of people. Sierra doesn't shy away from the accusations that he is as much a cause of these inequalities as a part of their effects. He's not the cure to the ills of society, just another symptom. Indeed, Sierra's harsh reflections on the racial or social hierarchies inherent in capitalist systems are not without their repercussions, but it is for each individual to decide whether the human suffering he highlights is ultimately his fault or our burden to share. The very definition of political art is that it should take a stand or

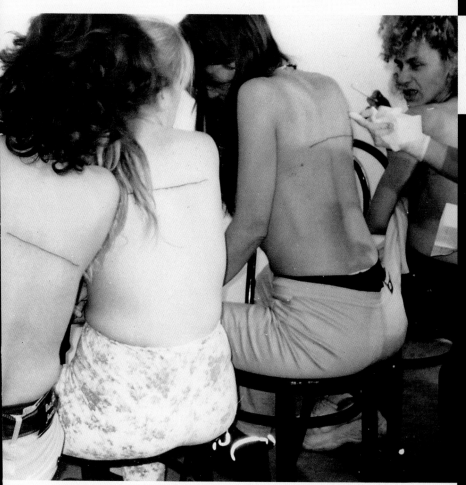

voice an opinion, although very few of us believe an artistic statement or position could ever actually change anything in the real world. Certainly *we* don't have to do the back-breaking work or accept Sierra's offers of employment. We just watch and pretend to care afterwards. Clearly that's not enough.

SOPHIE CALLE

TAKE CARE OF YOURSELF, *2007*

Arguably every time an artist puts paint or pencil to paper, clicks the camera shutter or signs their name on a canvas, they make an autobiographical statement – after all, every work of art is an assertion of ego. But in autobiographical (or confessional or emotional) art, contemporary artists take this notion of self-expression to an extreme and pour their very beings into works, as you might into a memoir or a love letter. The example here centres, not on a *billet-doux*, but on an email sent to the French artist Sophie Calle to end a long-term relationship with her. The title comes from the last line of her boyfriend's break-up text, a copy of which Calle eventually sent to 107 different professional women to ask that they respond and help her to 'Take Care of Yourself'.

Among others, the message reached a forensic psychologist, a crossword puzzler, a schoolteacher, a ballet dancer and even a cartoonist, all of whom were filmed or photographed reading and interpreting the goodbye note through their individual personal and/or professional lenses. Some offer solace, others a means of reconciliation or else retribution. A lawyer suggests a jail sentence and a fine for the ex (symbolically referred to as 'X' in the email), while a female clown mocks his written words. A sharp-shooting markswoman simply puts a few bullets through his cowardly missive. The cacophonous walls of video messages and different advisory voices put together by Calle for the installation of the work formed a kind of group therapy, bringing strength through the sheer number of responses, or at the very least some sisterly solidarity in the wake of her rejection.

However, whether her intention was to exorcize this romantic villain from her life or to aid in the process of lamenting a lost love is not clear, because the compounded effect seemed to be to enact her own vengeful and impersonal dose of pain on the mysterious Mr X in return.

> **'SHE ALLOWS US A VICARIOUS GLIMPSE INTO HER EXISTENCE AND INTO THE LIVES OF OTHERS THAT NO OTHER MEDIUM, GOSSIP COLUMNIST OR PAPARAZZO COULD POSSIBLY ACCESS'**

Calle has often focused her relentlessly obsessive works on previous partners, possible objects of affection and other affairs of the heart. She has asked friends and strangers to spend eight hours in bed with her, for example, and spied on a man by following him through the streets of Venice. Calle even gave up a year to adhere to a set of restrictive rules determined by another ex-lover and pieced together another man's life through his lost address book, which pushed the boundaries of privacy and intrusion to their limits. Whether you side with Calle's quest for these most intimate, forensic details or consider her tell-all style excessively voyeuristic, she allows us a vicarious glimpse into her existence and into the lives of others that no other medium, gossip columnist or paparazzo snap could possibly access.

Are the works just conceptual games? Once, while interviewing the defiant, sexy and spikily wilful Calle, I took issue with a particularly uncomfortable piece of hers

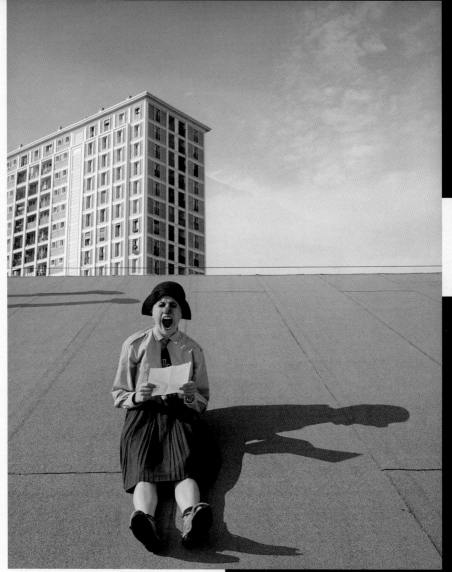

(*Couldn't Capture Death*, 2007) in which she filmed her mother's dying breaths. The artist promptly broke down in tears, making me realize that her work represents authentic and invested psychological engagements with topics close to her and that they are not just coldly conceptual works of art. They are all, it turns out, painfully real.

I received an email telling me it was over.
I didn't know how to respond.
It was almost as if it hadn't been meant for me.
It ended with the words, 'Take care of yourself'.
And so I did.
I asked 107 women (including two made from wood and one with feathers), chosen for their profession or skills, to interpret this letter.
To analyze it, comment on it, dance it, sing it.
Dissect it. Exhaust it.
Understand it for me. Answer for me.
It was a way of taking the time to break up.
A way of taking care of myself.

CHAPTER 4:

ART AS EVENT

'LIFE IS JUST ONE DAMNED THING AFTER ANOTHER.'

ELBERT HUBBARD, THE PHILISTINE, 1909

A young, hooded man is hell-bent on trying to break into a car, forcing the window with a wire coat-hanger and kicking repeatedly at the stubborn door. Or rather, to describe events more accurately, a South African artist named Robin Rhode has strolled into a respected Italian collector's pristine new foundation in the suburbs of Turin, drawn a sketchy outline of an automobile in charcoal on one of the white walls and proceeded to perform his short-lived piece *Car Theft* (2003) in front of me and other startled guests.

In such polite company, among a crowd of local Turinese dignitaries and prominent figures from the international art scene, the sight of this violent, futile act is certainly a jolt to the normally sedate proceedings of an evening private view. As Rhode's thin, athletic frame – his street-casual demeanour also at odds with the sharp suits around him – continues to huff and puff at this imagined heist, it's as though the confines of the gallery begin to drop away, reminding me there's a real world outside, one that only rarely threatens to break into the hallowed halls of our museums. The scuffed exertions of the artist's feet and bruising shoulder charges on the wall – increasing the smudginess of the car's black outline until they are almost unrecognizable – are also a reminder of an illicit, nocturnal activity that might well be second nature to

Robin Rhode, <u>Car Theft</u>, 2003, Walker Center, Minneapolis, video, 5 mins 25 seconds

Xu Zhen, <u>In Just a Blink of an Eye</u>, 2005, performance

some passers-by in the gritty, working-class San Paolo neighbourhood that surrounds this cocooned exhibition environment, as well as something that was likely a daily occurrence on the streets of Rhode's native Johannesburg when he was growing up.

Aside from the frisson of excitement caused by such perceived illegality in an unexpected setting, Rhode's fleeting, physical action has stayed with me as vividly and for as long as many far more substantial, sustained encounters with permanent pieces of contemporary art. Indeed, this category of 'Art as Event' includes more than conventional performance pieces. It could also include any or all of the following: a lecture, a dance, a gig, a demonstration, a procession, a séance, a reading, a phone call, an interaction or anything else that can be scheduled or timed. It might be private and personalized, or public and free-flowing. It could be continuous, like a television channel, or contingent, like chancing upon a person asleep (both of which have been incorporated into recent performance pieces). With so much of today's art involving audience participation or visceral experience and so many of its objects becoming indeterminate

and fleeting, maybe all that is left is a memory, a remnant, a photograph or a video.

More often than not with this genre of art you will have already missed the event – it's gone, never to be repeated. Early performance pieces will only be available in the future as scraps of text, black-and-white photographs and some grainy video footage. Recording contemporary performance for posterity is less of an issue nowadays given the leaps in technology and equipment, but the documentation – another kind of background or backdrop to its understanding – is still vital for its survival.

Given that my own evaluative structure, the *tabula rasa* principle, is premised on having a prolonged period of contemplation with a work that you might otherwise breeze past in haste, the issue of performance art's ephemeral nature is problematic and yet also central to its understanding. Trying to tabulate a piece of performance art based on my mnemonic formula might initially seem doomed to failure, given that, as in the case of Rhode's *Car Theft*, the work might not involve very much T for Time. Similarly, the uniqueness of every staged event means that it may not be feasible to use the L to Look Again. Conversely, there can be far too much time available to spend with this category of art and simply too many opportunities for repeat viewing, given that many performers pride themselves on durational or stamina-testing pieces. I have previously entered rooms where someone, often ostensibly unaware of my presence, has been engaged in an activity of some kind – cutting paper, hairdressing, fondling themselves while reading, sitting naked on a plinth, dancing to headphones in their sparkly underpants and so on – only for them to keep on carrying on, presumably long after I was gone. Twice, for example, I've walked in on a seemingly static work by a controversial Chinese artist, Xu Zhen, titled *In Just a Blink of an Eye*, in which a performer hired by him (often an immigrant) is bent over backwards in mid-air, as if blown over by a strong wind. Twice I have puzzled as to how this person was frozen in their gravity-defying, back-breaking pose, as if a pause button had been pushed (if you must know, there's a supporting structure hidden beneath their clothing).

ONLY CONNECT

If Time is necessarily of the essence in all performance work, then the next letter in the *tabula* formula, A for Association, is equally important to its impact. In fact, perhaps the greatest live piece I've seen was titled *These Associations* (2013) in Tate Modern's Turbine Hall, involving as it did some of the most heartfelt interactions with real people I've ever had in a gallery, whether scripted or not. Groups of players, orchestrated by Berlin-based artist Tino Sehgal, ran and swarmed around the empty concrete space, only for individuals among them to occasionally stop charging around to tell stories and chat to visitors. 'I have a phobia about bridges,' one lady confided to me; I agreed that my own vertigo might be caused by the same internal imbalance she felt. A young girl told me about the 'slutty kitty' she saw being fed at various houses on her street; I admitted that my cat did the school run for affection too. In other participatory works by Sehgal, I have been whispered at, sung to by a choir in a pitch-black hall, led around an exhibition by a personal tour guide and confronted by a child actor playing a fictional cartoon character. Yet, rather than simply having to recalibrate my personal boundaries or typically British inhibitions through a forced, touchy-feely interaction, the thrill of *These Associations* was that of having an unexpected dialogue and of sharing some memories with another human being. Sometimes it's good to talk to strangers.

ALL WORK AND NO PLAY

As liberating and stimulating as performance can be when you are there, in the moment, there is often more to appreciate beyond that which first meets the eye or greets the beholder in a space – which is where the B for Background comes in. Performance artists have always invested not just time but also considerable effort in their work and have been known to take their commitment home with them. Perhaps the most extreme exemplar of the protracted performance is a Taiwanese artist from New York, Tehching Hsieh, who started making demanding, drawn-out works in the late 1970s. He spent an entire year of his life outdoors, as well as 365 days indoors during which he denied himself any knowledge of the outside world, and the same period again punching a time clock, every hour on the hour. This kind of gruelling unseen labour

Tino Sehgal, <u>These Associations</u>, 2013, Tate Modern, London

Antti Laitinen, Bark Boat,
2010

or self-containment does not fall into the realm of invisible, conceptual art simply because the endeavour is evidently real. Instead it gives the artist's struggle an epic, enduring quality.

While Hsieh retired from his punishing routines in 2000, other artists have taken up his mantle of persistent, perspirant performance, including a young Finnish sculptor and performer, Antti Laitinen, whom I once met building a boat entirely out of strips of birch and pine that he intended to row across the Gulf of Finland to Estonia. He'd previously built his own one-man island and lived in the forest for four days with no clothes or food, so was used to making works that no one would witness at the time of their making, having instead, like me, to rely on looking back at his films, photos or sculpted relics, after the fact. I asked Laitinen what possessed him to want to set out on such uncharted journeys and he replied: 'In Finland, kids make little boats from bits of bark that they put in the water, as if they were sailing them on a great sea. My studio is on an island with lots of dead trees, so I collected the bark to see if I could make this romantic notion a reality and sail across the sea.' Being half-Finnish myself, I could immediately relate to (or Associate with, to use my own rubric) his staunch work ethic and his desire to be at one with nature. This is when an artist's Background or nationality can inform the understanding of a work, just as Hsieh's status as an illegal immigrant when he arrived in the US added poignancy to his decision to lock himself in a cage for a year.

SHUT UP AND DANCE

Let's move on from B for Background and turn to the possibility of how best to Understand performance art. I have already mentioned those artists who invest hours on end burying, suspending, bathing, flagellating, binding and more generally just displaying themselves, but such exceptional feats can seem so far removed from how we live our normal, sane lives as to be utterly alien in sensibility. For instance, I've never been tempted to usurp and annex a gallery as the self-proclaimed king of my own micro-nation, or attempt to channel the spirit of birds or animals through shamanic rituals, though I have watched intently as others have done so in front of me.

In order to make more sense of what's surrounding you or involving you, it can be helpful to think of a temporal event in

terms of another art form that it might resemble or take inspiration from. The Argentine-born British artist Pablo Bronstein, for instance, makes moveable furniture, sets bodies and sculptures to music, and stages entire ballets, the clear difference between him and a professional choreographer being that his work derives from architecture and often interprets the built environment through the medium of dance or performance.

Getting an initial grip on the influences behind a performance can spark off previously hidden meanings, as was literally the case when I was met with a space full of dozens of hanging rings, of the kind usually used by gymnasts. The installation, unhelpfully titled *The Fact of Matter* (2009), was obviously meant for me to tackle as an obstacle course, working my way across this athletic field of interaction, one hand or foot hold at a time, in an ungainly and, as it turned out, frankly embarrassing manner. It was only when I discovered that the creator of the piece was William Forsythe, a dancer by trade, that I started to understand what kind

of discipline was being requested of me, physically and mentally, and how my movements might mirror those of a body going through space in another context, as though on stage. Needless to say, the performance is often only as good as its performer and I was woefully inadequate to gracefully or successfully enact this particular work, but it is as close as I have ever got to taking part in either gymnastics or acrobatic dance moves.

Sometimes it's the location that aids interpretation, just as much as the form. Another choreographer, Jérôme Bel, known for his unconventional live shows in which his protagonists variously sing while wearing headphones or continuously get dressed and undressed, creates boundary-stretching theatrical spectacles as much as anything approaching conventional dance, which is why the Belgian's work is so often shown in an artistic framework or museum setting. In 2012, I saw his *Disabled Theatre* in a small German cinema. A travelling troupe of eleven actors with differing degrees of learning difficulties and mental disabilities

Left: Pablo Bronstein, Tragic Stage, 2011

Jérôme Bel, <u>Disabled Theatre</u>, 2013

took it in turns to stand on stage and discuss their involvement with Bel's production and their emotions about their own conditions, before each performing a song and dance of their choice at the end. This wasn't like any live show, performance or play I'd seen before, or have seen since, and felt more like mass therapy or a journey of discovery, perhaps similar to the one Bel embarked on when first deciding to work with this Swiss group (called Theater Hora), whose members display a wide range of developmental difficulties, ranging across the spectrum from mild Asperger's to Down Syndrome. My own reactions while watching *Disabled Theatre* veered from initial trepidation and scepticism as to the possible merits of exposing mentally vulnerable people in this way, to periods of patronizing sympathy

William Forsythe, <u>The Fact of Matter</u>, 2009, installation view

and misplaced empathy, before eventually giving way to a profound respect for the performers and an odd elation as the curtain fell. I was no closer to a comprehension of their distinctive disorders or what it might be like to live with disability. All I knew was that I had shared something special, spiritual, even beautiful, with a brave and wondrous handful of individuals; something that might at a later date trigger something approaching understanding. (Note my own confused, continued use of the word *something* in that sentence – contemporary art is nothing if not ambiguous, contrary and elusive, often frustratingly so.) Maybe there's a higher calling beyond mere comprehension. Perhaps an artwork can represent a marker in one's life or act as a rite of passage.

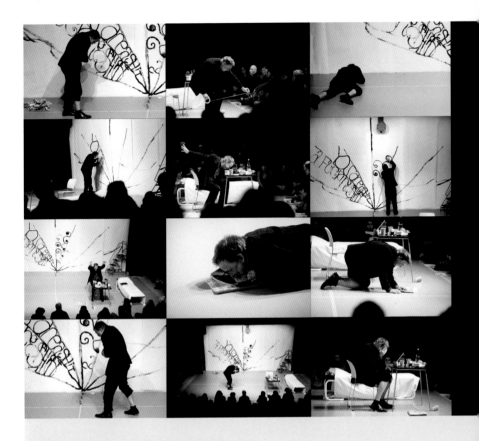

ARE YOU EXPERIENCED?

This process of doubting and questioning what you're seeing can elicit the strongest of reactions and the clearest of meanings. I've sat in a museum and watched an American artist, Matt Mullican, as he regressed, recoiled, drew obsessively, scratched himself, cursed, chanted, and rocked back and forth in his chair – all while he was under hypnosis. He screamed repeatedly that he was faking it, but appeared almost possessed by another being and consequently so out of it that I just couldn't be sure. Such misgivings, of course, hampered my ability to appreciate Mullican's work at the time, but again as a spectator the best technique is to embrace the unfathomable and suspend disbelief, even if it's only for a minute (a retrospective Look Again, if you will). If that sounds like a plea for putting your faith in contemporary art, then so be it.

As with previous categories put under the scrutiny of my *tabula rasa* approach, the increasing hybridization of contemporary art requires that you maintain an open mind – or literally start afresh and wipe clean your preconceptions – when approaching any medium or means of artistic delivery, whether it happens in the

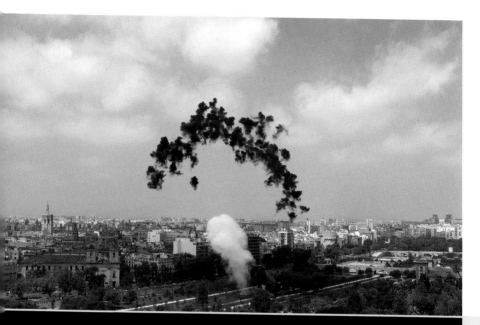

Left: Matt Mullican, Under Hypnosis, 2007, performance views

Cai Guo-Qiang, Ignition of Black Rainbow: Explosion Project for Valencia, 2005

gallery, the theatre or the street. Art can be anywhere, it can happen anytime. That said, I've often wondered about the status of art that exists after the event as nothing more than a vision, a half-remembered recollection or a rumour. The pyrotechnic displays of the Chinese artist Cai Guo-Qiang, for example, obviously relate back to the discovery of gunpowder and the invention of fireworks by his homeland at the end of the first millennium, but what lasting impression can they possibly leave, beyond a few whizzes and bangs? The snaking patterns of fire or blooming explosions he specializes in often only last for a few seconds and can be celebratory, communicatory or commemorative, as was the case with *Black Rainbow: Explosion Project for Valencia* (2005), a daytime arc of detonations created in the latter location that paid tribute to victims of a terrorist attack on Madrid.

Even if there's no object at the end of the event – and I've been told that the cocktails, meals, smells, lights, music and even different qualities of air in front of me have constituted the art I was meant to be experiencing – there should, at the very least, be a point that's being made. This leads us on to the next chapter on 'Art as Message'.

SPARTACUS CHETWYND

A TAX HAVEN RUN BY WOMEN (IN THE STYLE OF A LUNA PARK GAME SHOW), *2010*

'Turner Prize nominee lives in a nudist colony!' 'A wacky beard-wearer who calls herself Spartacus re-enacts Bible scenes with papier-mâché puppets!' Apart from the exclamation marks, which I've added for effect, this is what passes for headlines and newspaper commentary on Britain's most prestigious annual contemporary art award. Then again, when it comes to the madcap performances of Spartacus (née Alalia) Chetwynd, even the most erudite art critics are often lost for words. The artist and her travelling band of helpers have

busked their way around international museums for the past ten years, disrupting exhibitions with brash, theatrical interludes, interacting with puzzled visitors and generally leaving a trail of amused befuddlement in their wake.

It's 2011 and I'm sat on the floor in the middle of the Frieze Art Fair in London while Chetwynd (who has since renamed herself Marvin Gaye Chetwynd) and around thirty extras prance around me dressed as surreal seals and shambling tree-figures, or

'SPARTACUS, HER FACE SMEARED WITH BLACK MAKE-UP, LOOSELY CORRALS THE ACTION LIKE A DERANGED CULT LEADER'

else they're shrouded beneath the fuzzy fur of a giant cat, one of the players controlling each of its twelve legs. At the centre, her face smeared with black make-up, is Chetwynd herself, loosely corralling the action like a deranged cult leader. The half-hour-long piece purports to be a game show in which two teams vie for a chance to ride on this 'cat bus' to enter 'A Tax Haven Run by Women' – Chetwynd's fictional Shangri-La, where powerful female figures rule the economy. To be honest, I'm not following the narrative and there's no discernible dialogue, apart from Chetwynd's occasional, urgent instructions. Even if I knew that the artist had studied Marxist philosophy and had a love for the Japanese anime film *My Neighbour Totoro* (which features a similarly enormous flying feline), I probably wouldn't be any the wiser.

Yet there is an undeniably infectious energy to the whole show, which moves along at a furious pace, fuelled by a jaunty soundtrack that recalls another fantastical animated feature, *Belleville Rendezvous*. There's more than a whiff of bawdy medieval farce to the playlet too, as though court jesters and troubadours had been dragged forward in time to perform homages to Chaucer or Rabelais. It is funny and far from polished, but after a few preliminary giggles at the silliness of it all, I begin to feel hypnotized by the swaying and constant movement, before a more general unease begins to settle over me. Between the raggedy costumes and bloated, indeterminate sea creatures, there's something disturbing about Chetwynd's wonky, homemade

aesthetic. After a rash daydream that this could suddenly turn into some bloody, orgiastic pagan ritual at any moment, I snap out of my daze, pull back from my intense focus on the performance in front of me and take stock of where I am and what it might all mean.

Even without hearing Chetwynd's explanation or the *Tax Haven* title – which, like all good titles, alludes to a possible meaning without actually giving one away – her decision to stage a transient, trashy performance among the conspicuous wealth and highly priced paintings of a commercial art fair is palpably rebellious. It's also urgent, liberating and peculiarly sincere. I can't necessarily say the same about the rest of what's on the walls. Is all art's value up there, in valuable pictures on walls or in six-figure shiny sculptures on the floor, rather than residing in what's writhing around in front of me or floating around my head? Suddenly I'm not sure anymore.

MARINA ABRAMOVIĆ
THE ARTIST IS PRESENT, *2010*

Marina Abramović has starved, cut, burnt, drugged, whipped and suffocated herself in front of audiences, even allowing others to knock her over, threaten her life with a loaded gun, and hold a bow and arrow to her heart. However, not content with simply revisiting some of these radical works from a forty-year career in performance art for her major retrospective exhibition at the Museum of Modern Art in New York, Abramović decided to stage a new piece – her most ambitious and punishing to date. For the entire 700-hour run of her three-month show, Abramović sat stock-still in the atrium of MoMA, silently inviting visitors to sit in the chair opposite her. Her staggering display of willpower, which involved no rest breaks and nil by mouth throughout, was matched by an unerringly expressionless face, although the same cannot be said for her approximately 1,500 sitters, many of whom cried or refused to return her penetrating gaze, with only one man daring to sit a full seven-hour day with her.

Although I missed her marathon staring match in New York, I did interview the Serbian artist about her experience later that year and felt some of her steely determination in our conversation. 'People think that the early work is more powerful or dramatic,' she told me, 'but mental endurance is much more difficult. Those performances I did of weeping or cutting lasted just one hour, but I can do more now because I've learnt so much about self-control.' The audience at MoMA could admire this strong, stoical woman as they walked past and even pay homage to her Herculean feat of endurance by sitting with her, sure – but I wondered what else were they seeing or feeling?

'MANY OF THE 1,500 SITTERS CRIED, WITH ONLY ONE MAN DARING TO SIT A FULL SEVEN-HOUR DAY WITH HER'

The Artist Is Present was arguably performance art in its simplest, purest form – it was merely a presence. As well as recalling the static, protracted nature of other lost art forms, such as portraiture and conversation, Abramović's sit-in was also a great occasion for the encouragement of the act of looking. We often feign interest in the things we see, or glance at works of art without really noticing them, meaning that we miss much of what life and art have to offer. Abramović's performances demand more attention and interaction from the casual onlooker, either by presenting actual bodily harm or by provoking a possibly wince-inducing reaction. We are emotional, empathetic creatures and therefore susceptible to images of others suffering or self-harming. But, more than mere sympathy, Abramović might also be making an impassioned plea for us not to ignore the vitality of art or take its very existence for granted or, as she put it to me: 'Art is like breathing. You shouldn't question it – you just do it or die.'

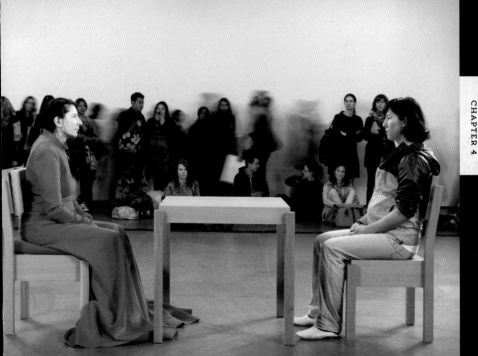

Miroslaw Balka, <u>Play Pit</u>, 2000

CHAPTER 5:
ART AS MESSAGE

'BUT IT IS USELESS FOR A CRITIC TO TELL
ME THAT SOMETHING IS A WORK OF ART;
HE MUST MAKE ME FEEL IT FOR MYSELF.
HE MUST GET AT MY EMOTIONS THROUGH
MY EYES.'

CLIVE BELL, 'ART AND SIGNIFICANT FORM', 1913

Wherever we look, we're constantly being bombarded with
messages and signs: stop, go; eat here; breaking news; no parking;
don't get in my way (indeed, body language is even more
ubiquitous than written signage). Even the clouds in the sky
might be telling us something about incoming weather or which
way the wind is blowing, but their formations and movements
first need to be deciphered.

Contemporary art, like contemporary life, is also a jumble of
competing clues, philosophical puzzlers and hidden agendas.
While previous chapters covered a trio of combative, spontaneous
and declamatory types of art that demand an encounter or an
active audience, the works in this chapter all require a modicum of
careful reading or visual decoding for them to reveal their secrets.
Often the meaning of a work of art might only sneak up on you
after a prolonged bout of viewing and strangely it's these quieter
pieces that can end up speaking louder and lingering longer in the
consciousness than even the most bombastic and overbearing of
art objects.

So it was when I found myself in the forests of southern Sweden
in 2000, at a small foundation and sculpture park nestled in a
vast Scandinavian forest. Unlike much outdoor art, the piece I

chanced upon at the Wanås Foundation didn't soar up in front of me, like the 27-foot-tall stainless-steel tree I'd just passed, *Impostor* by Roxy Paine, or surprise me, like the intimate bronze statue of a woman peeing next to a lake, by the Swede Ann-Sofi Sidén – which is actually a startlingly real cast of the artist herself, squatting down unselfconsciously.

No, what I initially hadn't noticed, and almost tripped into, was a hole in the earth that had been filled by dozens of those hollow little plastic balls beloved of toddlers everywhere, in bright yellow and blue, recalling the colours of the Swedish flag. I soon realized that the opening beneath me was obviously not a *Play Pit*, as the work's title claimed, but was meant to serve a more sinister purpose. Two protruding slabs of black granite on either side suggested this was really meant as a grave. However inviting the offer of diving into this coffin-sized ball pool was at first, it was quickly replaced with a sense of fear. I couldn't decide if it was just a deeply troubling one-liner – a dark joke playing on the opposition between the fun promised by the balls and the finality of the jaws of death – or whether there was something deeper buried beneath those jolly spheres, perhaps about the possibility of redemption or life after death. Long before I'd invented my *tabula rasa* system, this outwardly simple sculpture had already made me Look Again and consequently forced me to spend some quality T for Time with it and, unexpectedly, with my own mortality. Its seesawing mental after-image would continue to haunt and taunt me long after I had left that place.

The artist responsible, Miroslaw Balka from Poland, is not famed for his levity, although he has previously introduced snowmaking machines into a gallery and snapped pictures of his childhood teddy bear exploring his kitchen. He is better known for making disturbing sculptures and atmospheric installations that reference the Holocaust, specifically the extermination camps of Treblinka, which were used between 1941 and 1943 to imprison and then gas at least 700,000 people, which included about two-thirds of the population of Otwock, a town just outside Warsaw, where Balka lives and works. While this is not something I can easily make an Association with myself, it's this Background that could shed some light on what Balka's message or messages might be.

Miroslaw Balka, <u>How It Is</u>, 2009

His more recent, walk-in work for Tate Modern's Turbine Hall, entitled *How It Is* (2009), was an ominous incline leading up into an enormous pitch-black box, which felt like being led inside a giant metallic container used for the trafficking of human beings. Arguably, this experiential journey into darkness hinted at some level of Association – obliquely alluding to the *Judenrampe* slope that led to Treblinka's transportation trains – although it's painfully obvious that no work of art could ever match such an incomprehensible feeling of horror and helplessness. Instead, Balka's black hole slowly came to represent different dead-ends, caves, shadowy corners and holding pens in my mind. Balka even refers to it in a list of preparatory ideas as resembling the entrance to his own cellar. Similarly, when grasping for an

understanding of his *Play Pit*, it felt too generic and too far removed geographically to relate to any specific location, such as the Jewish cemetery in Otwock, which the artist is known to visit regularly.

Despite not fully managing to follow my own *tabula* structure in strict order when thinking about *Play Pit* – skipping past B and U straight to the letter L and then back to T and so forth – I got there in the end. In tackling the final A for Assessment, more than a decade later, the ball-tomb has come full circle in my mind, through countless mental quandaries and flip-flops, back to relative simplicity again. For me, it not only stands in for the conflicting highs and lows experienced throughout the cycle of life, between birth and death, but it represents a moment of innocence that separates a carefree child's play from its as yet unforeseen, but inevitable, end. It's also a reminder to me that contemporary art is often a trap you can fall into all too easily, because what you see is hardly ever exactly what you get.

FROM HISTORY TO THE 'HOOD

A truly memorable or meaningful work of art shouldn't rely on just one overriding message, but should present multiple solutions. Just as Balka proves he's not all doom and gloom by fostering less explicit interpretations of his work, so the best contemporary artists also embed meaning in their work in similarly multilayered strata, often leading to wildly different interpretations among viewers. A young French artist of Algerian descent, Mohamed Bourouissa, for example, created a series of large-scale photographs called *Périphéries* (2005–08) that depict street kids from the outlying Parisian suburbs or *banlieues*, which are areas of towerblocks and housing estates located beyond the Paris ring road, or La Périphérique as it's known. These images can be read in various ways. They are artfully lit, composed and shot, but resemble photojournalistic reportage in their subject matter, clearly referring to the recent Paris riots of 2005. Bourouissa's photographs can be read through the lens of art history too, with many of their poses and compositions borrowed from canonical painters such as Caravaggio, Géricault and Delacroix, whose famous 1830 canvas depicting the French Revolution of nearly half a century before, *Liberty Leading the People*, clearly influenced Bourouissa's *La République* of 2006.

Mohamed Bourouissa,
Périphéries: La
République, 2006

The newer of the two images features a young girl (personifying *Liberté*) clutching the Tricolore flag of France, while all around her are black youths, scuffling or gesturing in a way that suggests they are mounting their own revolution on the streets of Clichy-sous-Bois, where the burning of cars and civil unrest began the previous year.

My method of looking at contemporary art presupposes no such art-historical knowledge of French painting, of course. However, there are some clear indications that *La République* and other

Yael Bartana, <u>And Europe
Will Be Stunned</u>, 2007–11

works from *Périphéries* might actually be carefully stage-managed images, rather than opportunistic snapshots. Bourouissa's figures tend to huddle theatrically, or else cluster in neat conspiratorial groups. Each of their actions is frozen mid-gesture, while the strong lighting is reminiscent of cinematic or televisual depictions of gangsters. The realization that these photos are in fact elaborate set-ups alters their meaning radically, leaving us to ponder whether Bourouissa is heroizing, glamorizing or glorifying his subjects as liberators of the downtrodden and disenfranchised, or purposefully perpetuating the view of them as violent insurgent immigrants, in the demonizing way that the news media so often do.

FIGHT FOR THE RIGHT PARTY

The inbuilt ambiguity of much contemporary art can be infuriating for the viewer, who has to juggle the role of judge, jury and executioner while the artist merely presents his or her case in any oblique register they choose. Yet all the doubting and questioning form part of the process of appreciation and can lead to a more nuanced understanding of a topic, theme or philosophy. Take the case of a fictional political party, the Jewish Renaissance Movement in Poland (JRMiP), created by an Israeli artist, Yael Bartana, for a trilogy of films entitled *And Europe Will Be Stunned* (2007–11). The stated mission of the JRMiP is to reverse the Jewish exodus to Israel and repopulate Poland with a community that was almost entirely eradicated by the Nazis before the mid-point of the twentieth century. Yet Bartana's message of increased diversity and emancipation is paradoxically delivered through the very sorts of tub-thumping speeches favoured by fascist groups, while the movement itself is fronted by uniformed followers bearing sinister, crested armbands. In her three propaganda-style videos, we watch as attractive Israelis, dressed in kibbutznik headscarves and workwear, start rebuilding the famous Warsaw Ghetto from scratch, replicating its barbed-wired fences and watchtowers (indeed, some of the Varsovian onlookers, strolling through their local park, do look a bit stunned). The final instalment sees the charismatic figurehead of the movement gunned down in his prime, only for his spirit to live on in a giant Lenin-style monument and in the teary eyes and rousing songs of his zealous acolytes.

While presenting us with a utopian ideal of religious tolerance – that the previous rifts and ill deeds of a generation or of an entire nation might be healed or undone – Bartana does so in such an unpalatable manner, using such uncomfortable iconography, that it briefly shortcircuits our grasp of politics and strands us in a moral, geographical no-man's land. My head spins just thinking about it, but to confuse matters further, Bartana has since held real-life congresses dedicated to the aims of the JRMiP, asking Europeans to consider repatriating exiled Jews to Poland. This bleeding of political art into the real world confronts the question often posed to some of our more ambitious artists: can art ever really change the world? To which the short answer is almost always, unfortunately but honestly: No.

SOLDIER ON

Still, some contemporary artists refuse to lie down so easily and are becoming more insidious and less respectful of governments and ruling ideologies than ever before, to the point where they threaten to rise up, take charge and push the buttons themselves. One such project, which sadly never got the chance to enact its wide-ranging political consequences in the public arena, was the British artist Steve McQueen's proposal to print the faces of British soldiers killed in Iraq on a set of memorial stamps. Entitled *Queen and Country* (2007), McQueen's commemorative series of 160 miniature portraits prompted a debate in the Houses of Parliament and a lengthy campaign to persuade Royal Mail to release them as official stamps, but the work was only ever shown in museums and galleries, perhaps because of sensitivities surrounding the distribution of such ready reminders of the casualties of war, or simply because to do so would be to accept some responsibility or culpability for those deaths. The artist himself refused to lay blame at anyone's door, stating that his idea was neither pro- nor anti-war, surely out of diplomacy for the families of the deceased and due to his own position as an official war artist. McQueen's proposition remains potent and problematic in its unpublished limbo, perhaps more so in that it placed the state in an awkward position and was never successfully co-opted by the powers that be.

Art based on politics runs the risk of being as hectoring and didactic as the real thing, as was the case when I was greeted a

LANCE CORPORAL BENJAMIN HYDE ADJUTANT GENERAL'S CORPS (ROYAL MILITARY POLICE) DIED 24 JUNE 2003 AGED 23

Steve McQueen, Queen
and Country, 2007

Allora & Calzadilla, <u>Track and Field</u>, 2011

few years ago by the startling sight and deafening racket of an upturned, 52-tonne Centurion tank rumbling away outside the United States Pavilion at the Venice Biennale, which was being used as an *ad hoc* running machine by an athlete wearing the kit of the American Olympic team. Entitled *Track and Field* (2011), this performative sculpture was the work of a Puerto Rico-based duo, Jennifer Allora and Guillermo Calzadilla, who turned the opportunity to represent the USA into an occasion for ridiculing the nation's warmongering ambitions and foreign-policy posturing. As obviously impactful and attention-grabbing as the hulking, clanking tank proved to be at the time, its blunt message hasn't lingered long in my mind and, on reflection, was spoiled by the addition of a standard exercise treadmill for the athletes to actually jog on, rather than on the tank's tracks as I had wrongly remembered it. Nobody goes to art exhibitions to subject themselves to a party-political broadcast, so any such strident statements are better off tempered by some level of sophistication, which thankfully was present in Allora & Calzadilla's accompanying film work in Venice, *Half Mast/Full Mast*, which showed similarly athletic performers, dressed in

civvies, grabbing a vertical pole and suspending their bodies horizontally to create a succession of human flags. This video still contained an implicit criticism of the US, given that the filming took place on the island of Vieques, off the coast of Puerto Rico – used as an American naval base and weapons-testing site until 2003 – but here the Herculean efforts of the hanging participants speak of defiance and struggle in the face of adversity, rather than the sloppy symbolism of that brutish tank running on rhetoric.

MAPPING THE TERRAIN

Another example of a veiled or subtle act that can create wider political ripples without recourse to artistic bluster is *The Green Line* (2005), one of many walking (rather than sprinting) works of art made by a Belgian artist, Francis Alÿs. The work's subtitle – 'Sometimes doing something poetic can become political and sometimes doing something political can become poetic' – reveals something of his sensitivity towards the issues at hand. Alÿs had already dribbled a trail of blue paint leading to and

from one of his exhibitions on a neighbourhood amble in 1995 (titled *The Leak*), but he chose the more charged surroundings of the Israeli-Palestinian border to perform *The Green Line*, in which he followed the original boundary delineation pencilled on a map of Jerusalem in 1948, which carved up the territory as part of a ceasefire. In his film, voiceovers from both sides of the divide discuss the present reality of the situation, while Alÿs passes through armed checkpoints and past sections of the physical separation fence with his cans of dripping paint (totalling 58

Francis Alÿs, <u>The Green Line (Sometimes Doing Something Poetic Can Become Political and Sometimes Doing Something Political Can Become Poetic)</u>, 2005

litres), gently sending up the notion of a geopolitical demarcation through his haphazard 24-kilometre graffiti-strewn trek. That such a harmless gesture might have real-world resonances proves that it's when politics functions as an undercurrent to contemporary art that it's at its most effective, not when sledgehammering away at a topic that will be forgotten as soon as yesterday's news.

GLENN LIGON

WARM BROAD GLOW, *2005*

Neon didn't become thought of as a medium for making art with until the 1960s, when so-called Minimalist and Conceptual artists began plundering hardware stores for materials that, as the pioneer of fluorescent-light installations Dan Flavin once wrote, 'lack the look of history'. Those same artists also made words and instructions into formulae for artworks that could exist just as easily in the mind as in front of the eye. Glenn Ligon's 2005 neon sculpture *Warm Broad Glow* updates the language of Conceptual art for the new millennium, adding to it the insight and political standpoint of a gay black man, rather than those of the typical, white, male American normally associated with such avant-garde moments in twentieth-century art.

The twisted tubes of electric light spell out the phrase 'Negro Sunshine', although, in a reversal of normal neon signage, each letter is outlined with thin strips of black paint covering the front, not the back, as is customary. This barrier casts the light away from us, towards the wall, creating a halo and, indeed, as the title suggests, a 'Warm Broad Glow'. A little Background is useful here as both the title and the text 'Negro Sunshine' are drawn from a passage in a 1909 novella, *Melanctha*, by the writer and collector Gertrude Stein, in which she

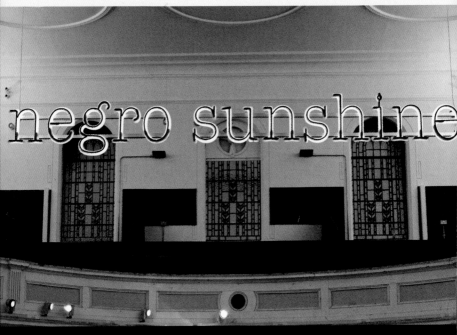

describes one of her black characters in racially stereotypical terms based on some notion of sunny, earthy, African-ness. Ligon has tackled the thorny subject of prejudice before, especially in two entirely identical photographs he presented of himself in 1998, titled alternately: *Self-Portrait Exaggerating My Black Features/Self-Portrait Exaggerating My White Features*.

'THE WORDPLAY IS ENOUGH TO CONJURE IMAGES OF DARK AND LIGHT, OF FREEDOM AND OPPRESSION, AND OF SOLAR OR LUNAR ECLIPSES'

It's not necessary to get the literary reference in Ligon's neon, though, since the wordplay is enough to conjure images of dark and light, of freedom and oppression, and of solar or lunar eclipses. In its simplest terms, it is a conceptual piece about opposites and difference that also addresses the impossibility of obtaining a truly black light or perceiving black sunshine. Ligon paints in words too, often in thick black oil on plain white or blackened canvases, and one of his most frequently quoted and stencilled texts, by the African-American writer Zora Neale Hurston, reads: 'I feel most colored when I am thrown against a sharp white ground.' This could be an apt visual description of Ligon's *Warm Broad Glow*, because although it's a scathing comment on existing social hierarchies and past civil-rights struggles, it's also an honest

admission of the graphic beauty and visual clarity that comes with such contrasts.

However you read Ligon's work, it is more than just a racially motivated minority report. Nothing is simply black or white, negative or positive, as it might once have seemed for those early Conceptual artists working with new linguistic ideas and non-physical forms for the first time. Instead, Ligon instils a typically brash, harsh material with a sophisticated, poetic sensibility and shows how to give the humble neon sign a sense of history and relevance too.

AI WEIWEI

COLOURED VASES, *2010*

Perhaps the most obvious anchor for any work of art that appropriates other objects from the world is Marcel Duchamp's infamous inverted urinal, *Fountain* of 1917, which represents the irreverent wellspring from which so much twentieth- and twenty-first-century art can be sourced. Although this radical gesture of recontextualizing 'ready-made' (as Duchamp called them) items of commonplace, shop-bought origin is now a hundred years old, the idea that artists might use found objects as part of their armoury of materials actually goes back much further, to Ice Age man's carving of bones, mammoth tusks or rocks that already resembled torsos or animals. This practice comes full circle in the staunchly anti-authoritarian Chinese artist Ai Weiwei's series of works involving Neolithic vases (c. 5000–3000 BC) and Han dynasty ceramics. In 1995 he made a photographic piece that depicted him *Dropping a Han Dynasty Urn*, while the year before he'd painted a familiar American brand name onto a similarly precious bit of pottery for *Han Dynasty Urn with Coca-Cola Logo*. Since then he has dipped an array of Neolithic vases in industrial paint, salvaged ancient church doors to create giant temple-like ruins and improperly restored antique bits of Qing dynasty furniture in an ongoing questioning of cultural value, originality, history and modernity, with an uncanny relevance for audiences both in China and in the West.

Politics always bubbles to the surface in Ai Weiwei's work, as it did when he recovered 150 tons of twisted steel bars from collapsed schools after the devastating Sichuan earthquake of 2008, only to flatten and restore their original, neat shapes for his imposing installation *Straight* of 2012. On the same topic, he hung over five thousand rucksacks from the façade of a museum in 2009 to commemorate the estimated, but never officially substantiated, number of children killed in the same natural disaster that had so many unnecessary, manmade consequences.

While his activism and outspoken stance on Chinese repression has brought him to the attention of his own government's police force as well as the worldwide media, Ai's art contains and conceals far more inflammatory thoughts than those published in his interviews or on his social-media timelines. For example, his decision to transport 1,001 Chinese citizens – none of whom had never left the country before or even held a passport – to Europe in 2007, for his performance piece *Fairytale*, was itself tinged with the very methodologies of identity control and human relocation that he was highlighting. His 2010 Tate Modern Turbine Hall commission, *Sunflower Seeds*, in which millions of tiny porcelain replica seeds were handmade by craftsmen in his homeland, was likewise both a comment on and a perpetuation of the belief that China produces an endless stream of technically proficient , but eminently throwaway reproductions. Being commercially successful while working within the

'AI WEIWEI EMBODIES OR APPROPRIATES THE SELFSAME CHINESE CONTRADICTION THAT REFUSES TO WHOLEHEARTEDLY EMBRACE OR DENOUNCE EITHER MODERNITY AND MANUFACTURING OR THE IMPORTANCE OF RESPECT FOR HISTORY AND HERITAGE'

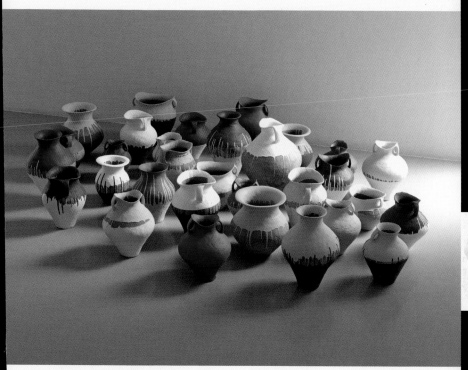

constraints of a Communist regime, Ai Weiwei himself embodies or even appropriates that selfsame Chinese contradiction. His work refuses to wholeheartedly embrace or denounce either modernity and manufacturing or the importance of respect for history and heritage. Ai's complex and challenging works, whether they involve artefacts he has borrowed, stolen, broken, changed, manipulated or had made for him, are as much about pillaging and plundering Chinese culture as they are about pillorying those practices or political finger-pointing.

CHAPTER 6:
ART AS JOKE

'WHATEVER IS
FUNNY IS
SUBVERSIVE,
EVERY JOKE IS
ULTIMATELY A
CUSTARD PIE.'

GEORGE ORWELL, HORIZON, 1941

It's not theatre, because there's no central stage or focus – it's happening all around me. It's not a one-man show or stand-up routine, as there's more than one performer leaping around and I can't make out any actual jokes being told. It might well be an installation, as the room is full of crummily made sculptures, hand-stuffed dummies or dolls, lumpy soft furnishings and crooked shanty-style structures as well, but I still can't be sure.

What I do know is that I'm witnessing some kind of improvised performance, entitled *Zero Hero*, by John Bock, who is clambering over his own creations, stuffing his head through empty shirts left hanging around the space and generally jibbering into a microphone for the dubious benefit of his captive audience. Did I mention he's wearing a pair of fake plastic buttocks?

The German artist stone-facedly refers to these frenetic live events of his as 'lectures', although the best description I can muster of the content and delivery of these madcap monologues is that they're somewhere between semi-academic, pseudo-scientific diatribes and nonsensical, stream-of-consciousness bits of psychobabble. Lampooning the dense, essayistic prose style of famous German philosophers such as Heidegger and Nietzsche, not to mention that of most contemporary-art theorists, Bock

Hero,
ce piece

employs unwieldy titles and illustrates his talks with portmanteau phrases such as 'ArtemisiaSogJod Mechwimper' or 'Approximation Rezipienten-bedurfniscomaUrUltraUseMaterial MiniMax'. Apparently the narrative underlying *Zero Hero* is based on the life of a young feral boy, Kaspar Hauser, who appeared in Nuremberg without any memory or the ability to speak in 1828, but there's no way of discerning that from what I'm watching. Besides which, I've since seen Bock perform versions of a DIY catwalk fashion show, a play of his own unhinged lifestory growing up on a farm, a gory horror movie with numerous vegetables being massacred and an adapted biopic of Henri Toulouse-Lautrec as a sex-obsessed dandy, and on no occasion was I particularly aware of these structuring narratives at the time.

As the pandemonium reaches a climax, the thrashing and ranting Bock suddenly falls from one of his strange, cloth-covered sculptures, landing on a clutch of well-heeled art-world types. I later hear that he broke a finger of the very collector who bought this whole rambling, sprawling riot of a show, although that may have been idle gossip or a prophetic metaphor for what owning such an amorphous work of art might feel like. Given that this took place during a frenzied week of museum openings and satellite events around a major art fair in Miami, you would be forgiven for thinking that this wasn't a terribly serious artwork in the scheme of things, but Bock – who studied economics and quotes poetry from memory – turns his own inaccessible, encyclopaedic erudition into absurd humour and a rip-roaring good show. He joins a long line of Surrealists and Dadaists intrigued by the intellectual potential of farce and slapstick, so it would be churlish to ignore him just because his work is amusing.

FUNNY-LOOKING

There's nothing worse than a bad pun or a joke that no one gets, so what makes a work of art funny rather than cringeworthy or painful to sit through? Well, art objects can be pretty obviously hilarious: I've seen an obese house with its rolls of fat squeezing over the door and windows; a giant, knitted soft-toy rabbit lying across a hillside like a prehistoric carved figure; a dirty mattress made to look like a couple lying in bed by suggestively placing two melons and a phallic cucumber next to each other; and, of

Tiger licking girls butt

Why do I have this urge to do these things over and over again?

Nathalie Djurberg, <u>Tiger Licking Girl's Butt</u>, 2004

course, an upside-down urinal presented as a sculpture, to name but a few examples. This kind of alchemical transformation of everyday materials, which so many contemporary artists now specialize in, can still tickle the funny bone – whether it's a bin bag or a cardboard toilet-roll innard painstakingly crafted from bronze and painted to appear lifelike, or a Viennese sausage enlarged to function as a public bench or piece of playground furniture. Everyone knows animals are funny – at least they are on those humorous home-video clip shows – and I've watched artists variously dress up as bears, rats and badger-pelted shamans; I've also seen a pen full of pigs with elaborate tattoos, as well as a claymation short film entitled *Tiger Licking Girl's Butt*. In fact, whatever kind of comedy you're into, there is an artistic equivalent, whether that be sight gags, sitcoms, one-liners or put-downs, while tastes for irony, satire, scatology, caricature, pastiche and parody are all well catered for too.

However, if there is a strong strain of humour to be found running through much contemporary art, it's barely tolerated and rarely acknowledged or respected as a sub-genre. But despite its lowly standing, it recurs and repeats like a persistent cough, infecting the staid environments of museums and galleries with much-needed lightheartedness, especially considering the normally po-faced seriousness we're treated to or expected to engage with. Take, for instance, the practice of Rodney Graham, a well-respected Canadian artist who nevertheless depicts himself variously as an amateur painter, a hermit, a poker player and a prison convict in his ongoing series of witty self-portraits. The idea that artists must take themselves and their careers seriously is directly rebuffed in Graham's deadpan video and performance work *Lobbing Potatoes at a Gong, 1969* (the date is disingenuous; he first performed the work in 2006). As the title suggests, Graham sits in a chair throwing potatoes at a gong about 15 feet away, apparently inspired by Pink Floyd's drummer, Nick Mason, who once used the same technique while on stage in London. It's not only a pointless, mundane thing for an artist to do – commenting on the futility of the creative act or the redundancy of most conceptual art ideas – it also ridicules the repetitive acts of early 1970s performance artists, such as the monotonous activities or exercises, done for hours on end, by Bruce Nauman or Vito Acconci, as well as Richard Serra's solemn act of flinging hot lead against a wall (*Splashing* of 1986). Graham's own punchline is a bottle of vodka on a nearby shelf that reveals what became of all those bruised potatoes.

ROFL (ROLLING ON THE FLOOR LAUGHING)

Although humour, like art appreciation, is subjective, there's no reason why comedic art shouldn't be subjected to the *tabula rasa* formula too, if only to aid in the understanding of a work's source of amusement. (Spoiler alert: there's still no guarantee of any sidesplitting laughter once we arrive at the final letter A.) Beginning with the T, we have already seen how important Time is to Graham's performance, with his frustrating routine of throwing and missing the gong threatening to stretch on into infinity (in truth, the piece only lasts for nine minutes). Yet, as we know, timing is everything in comedy and Graham's Sisyphean act wouldn't be funny if he didn't occasionally hit his target and elicit a thunderously satisfying crash.

Rodney Graham, <u>Lobbing
Potatoes at a Gong, 1969</u>,
2006

Ryan Trecartin,
<u>K-CoreaINC. K
(section a)</u>, 2009

Grayson Perry, <u>The Walthamstow Tapestry</u>, 2009, wool and cotton tapestry, 300 x 1,500 cm

Another fundamental tenet of humour is that it should relate to its audience, so the next letter, A for Association, is key for any artist looking to make us laugh. Coming somewhere between a bad pop promo, high-camp reality TV and an unholy mash-up of the worst traits of the internet is the video work of American artist Ryan Trecartin, whose onscreen exploits are simultaneously LOL (laugh-out-loud) funny and eye-poppingly excruciating (:–o in emoticon parlance). Trecartin and his cast of shrill, gender-bending characters talk in incomprehensible text-speak about identity, individuality and cyber-existence while pinballing around shonky, lo-fi sets and badly decorated apartments, like physical embodiments of online chatrooms. The action in works such as *K-Corea INC. K (section a)* (2009) and *Temp Stop (Re'Search Wait'S)* (2010) is hectic and dizzying, with the human avatars' squeaky chipmunk-voices having been sped up as though they were conversing on a cocktail of helium and amphetamines. Without an anchoring narrative, the comedy doesn't come from the suburban teen-inflected dialogue or the psychedelic pratfalls so much as from the recognition of the socially networked language and world that these lunatics are trapped in and the dawning realization that they're, virtually, us. Whether we can directly relate to his amped-up, YouTubed, Facebook-hooked users or not, Trecartin's savage, manic

jump-cuts between hysterical am-dram antics mirror our own increasingly attention-deficit, digitally addicted selves.

THE WORLD'S GONE TO POTTING HELL

If Trecartin makes your jaws ache and your brain fry, then the British artist Grayson Perry trades in a much gentler, more down-to-earth sort of comedy. His work is all about B for Background (with a smidgen of the aforementioned A for Association), charting as it does his own childhood fantasies, his social discomfort when growing up and his now fully blossomed sexual difference as the world's most famous transvestite potter. Although this dual outsider status, as a cross-dressing ceramicist, gained him notoriety and a Turner Prize in 2003, it's his caustic satire of every sphere of life – from the British class system and his own art-world status, to religion, politics and finance – that has resulted in such capriciously titled works as *Rumpleforeskin* (2005), *Art Dealer Being Beaten to Death* (2003) and *This Pot Will Reduce Crime by 29%* (2007).

Aside from featuring a procession of faintly autobiographical scenes, running from the womb to the tomb, Perry's stunning, 15-metre-wide *Walthamstow Tapestry* of 2009 also pays homage to ancient frescoes, batik textiles, Tibetan tankas, the Bayeux Tapestry and even Picasso's famous 1937 *Guernica* painting of a German bombing raid. On closer inspection the traditional weave and warp of the tapestry are punctured by discreetly

sewn-in brand names – Louis Vuitton, Pampers, Starbucks, Sony, Smirnoff, Visa, Apple, Ford and so on – because, like any good joke, too much long-winded preamble or shaggy-dog Background will only spoil the kicker at the end. *The Walthamstow Tapestry*, like Perry's piss-taking pots, accomplishes more than just cocking a cathartic snook at consumer culture because, tucked just beneath the grinning mask of humour, are some much deeper enquiries into the very foundations of our civilization, or the current apparent lack thereof.

It's all very well having a laugh, as many of today's practitioners undoubtedly do when making contemporary art, but does it really assist the viewer's U for Understanding (the next letter in this rib-tickling *tabula* rundown) in any way? Take the gross-out schoolboy japes of British siblings Jake and Dinos Chapman, who have clearly been having a blast in their joint career as artists – variously retaking their own adolescent art exams as

adults, adding realistic genitalia to the faces of child mannequins and balancing a waxwork Stephen Hawking on the precipice of a cliff in his wheelchair. By rights, such puerile pranks shouldn't register highly in art-historical discussion, yet the brothers have outlasted their own shock-tactic origins and survived being labelled as YBAs (Young British Artists) in the early 1990s. Whether depicting their own Nazi-inspired atrocities, in dioramas of murderous, disfigured model soldiers such as *Hell* (1999), *Fucking Hell* (2008) and *The Sum of All Evil* (2013), or tackling Western art's Old Master hierarchy by 'improving' or defacing original prints by Goya and Hogarth (both of whom would surely have been able to take the joke), the humour used by the Chapman brothers succeeds, first and foremost, by disarming us. Initially, their works make us smile or wince, thus briefly lowering our guard, before the true horror or implications of their messages hit us with the real, mental sucker punch. The joke is on us.

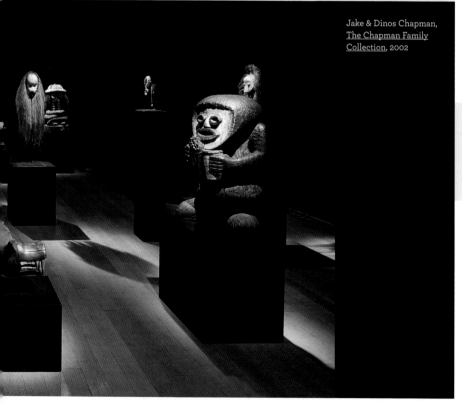

Jake & Dinos Chapman,
The Chapman Family
Collection, 2002

Of course, being the perverse beings they are, perhaps Jake and Dinos Chapman's greatest work to date functions entirely the other way around, even if the end result is the same. What appears to be an atmospheric installation of thirty-four hand-carved tribal sculptures and wooden fetishes from Africa is in reality a collection of elaborate fakes, depicting all manner of mutant McDonald's paraphernalia – featuring numerous golden-arch motifs, Ronald clutching a spear and Hamburglar disguised as a totem. Entitled *The Chapman Family Collection* (2002), the artifice extends to the supposedly remote tribal regions visited by the artists' forefathers in 'Camgib', 'Seirf' and 'Ekoc' (whose fiction is only revealed when read in reverse). Slowly, and this time by stealth, the Chapmans enhance our ultimate Understanding of objects by questioning where they came from and how they got there.

NOTHING TO SEE HERE

The hand of the artist is often similarly hard to detect in the work of Tom Friedman, cloaked as it is in the camouflage of the everyday. His clever manipulations, enlargements and multiplications of supermarket-sourced materials such as cereal boxes, plastic cups, tinfoil, toothpicks and bubblegum make him king of the double-take in art and so a good candidate to test the L and try Looking Again. A delicate, twisting, ochre-coloured sculpture of his, for example, is in fact a whole packet of spaghetti that has been cooked, dried and then connected end to end to form a continuous *Loop* (1995). It isn't necessary to look twice at his invisible pieces, however, two of which have involved Friedman expending *1,000 Hours of Staring* at a single sheet of paper (over a five-year period, 1992–97) and hiring a witch to put a hex on an empty pedestal for *Untitled (A Curse)* of 1992. But I challenge you not to stand mouth agape in front of his *Untitled (Pizza)* of 2013, salivating at the glistening strips of green pepper and at every carefully observed black olive, dough bubble and oven scorch. That someone would go to such lengths to pretend to fool a spectator who is surely already well aware that this wall-hung object is not a real pizza is reason enough to be cheerful and maybe even reason enough to return for a second bite – I mean, glance.

I warned you that the second A for Assessment might not leave you in the right kind of stitches because, to figure out whether

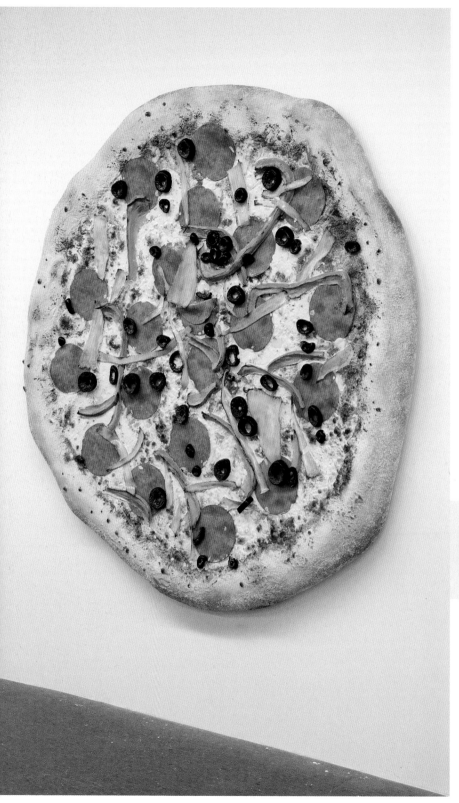

Maurizio Cattelan,
Bidibidobidiboo, 1996,
taxidermied squirrel,
ceramic, formica, wood,
paint and steel,
dimensions variable

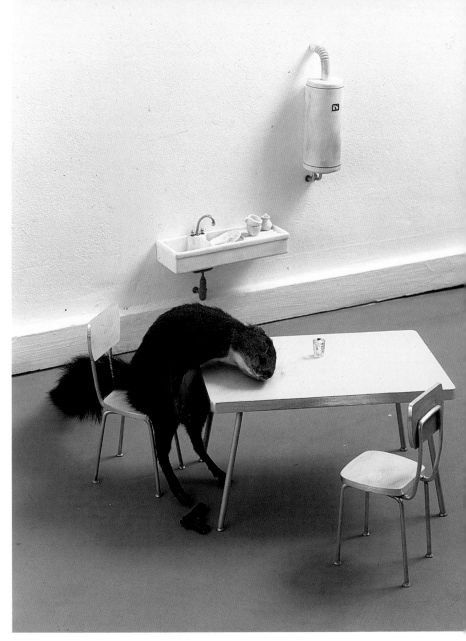

this kind of art is actually meaningful, we first have to ascertain whether the artists responsible mean any of what you think they're saying (if you know what I mean). I've always been equal parts delighted and troubled by the work of Maurizio Cattelan, who is one of the trickiest customers in the contemporary art canon. Ever since I encountered his stuffed, suicidal squirrel with a miniature gun just slipped from its death-grip (the first work of his I saw, in 1996), his taxidermied pigeons waiting patiently in the rafters of various art events (as if to crap on the unsuspecting gallery-goers below), his waxwork of the pope felled by a meteorite and various other effigies including a kneeling Hitler, two New York City policemen doing headstands and an old granny stuck in a fridge, I've struggled to locate any logic to Cattelan's chaotic, comic, character-driven output. At each turn he seems content simply to provoke scandal or self-deprecate, without following through with any of his thoughts or projects much beyond their painful births. His major retrospective exhibition at the New York Guggenheim in 2011, entitled *All*, simply entailed him stringing up almost every sculpture he'd ever made – including that poor squirrel – in a mass lynching of his whole career, before announcing that he was retiring as an artist. It doesn't matter if this was a genuine pronouncement or not, because insouciance and even hypocrisy are valid positions for artists to take and there are always one or two such jokers in the art world's pack at any one time. Using humour in art or even discrediting the whole shebang as a game, as Cattelan does, is incredibly liberating for artists (and for us), who are free to do what they want, when they want – although there's nothing funny about that.

DAMIEN HIRST
FOR THE LOVE OF GOD, *2007*

Being whisked past a security detail and ushered into a velvet-dark, plushly carpeted space to stand in hushed twos or threes at a time only added to the air of exclusivity that surrounded the first showing of Damien Hirst's *For the Love of God*. Glowing ethereally on its plinth and glinting dramatically in the spotlights, the diamond-studded skull quickly became the most talked-about art unveiling of 2007. I stood there, staring this death's-head in the face and waiting to be confronted by some revelation about my own mortality, or at least to feel the residual glow or charge being generated by 8,601 flawless diamonds set in platinum.

But it never came. Any grim or grisly connotations sparked by this empty cast of a human skull were countered by its preposterously precious armour. Instead of finding existential meaning in those hollow sockets, I was dazzled by the pink, tear-shaped stone sunk into old Yorick's forehead, and transfixed by his toothy grin with its comically unadorned enamel fronts. Seemingly obsessed by death, Hirst has always managed to combine great gravity with relative levity, or else to cloak the Grim Reaper in distractingly shiny attire, beginning with his enormous tiger shark swimming forever in formaldehyde solution, *The Physical Impossibility of Death in the Mind of Someone Living* (1991).

However, *For the Love of God* was not simply another amusing or arresting visual one-liner, but a troubling effigy of everything that had gone wrong with the art business and, to a certain extent, with all other kinds of business – from the moral corruption of bankers to the tasteless bling surrounding the world of showbusiness. The diamond skull was thus the very epitome of art in the age of luxury and represented the greed of super-rich collectors fuelling the market for objects of ever-increasing monetary value. In fact, Hirst was not alone in perpetuating this view of the art world as a high-stakes game of financial jeopardy.

> **'ITS VERY EXISTENCE SUGGESTS THAT WE ARE STILL OBSESSED WITH COLLECTING USELESS TRINKETS AND DESIGNER GOODS THAT WILL OUTLAST US – SIMPLY MORE THINGS THAT CANNOT COME WITH US WHEN WE DIE'**

Works of art are now routinely discussed in terms of price rather than aesthetic merit and artists are attached to league tables of earning potential. Measured by their auction records alone, famous pauper Vincent van Gogh and fellow French painter of humble scenes Paul Cézanne would be among the richest artists in history. Hirst's skull, supposedly worth £50 million, was only the latest in a series of artrepreneurial manoeuvres designed to land him a spot among that elite bunch of creatives.

However, it is not the cost of *For the Love*

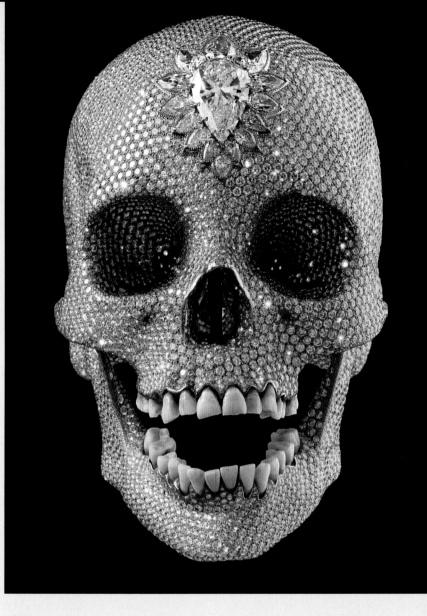

of God that makes it such a potent, albeit problematic, object of desire. Its very existence suggests that we are still obsessed with collecting useless trinkets and designer goods that will outlast us – simply more things that cannot come with us when we die. Yet, like the British Museum's notorious crystal skull – long believed to be an ancient Mayan relic, now revealed to be a nineteenth-century forgery – Hirst's glimmering treasure has the air of a fake or a figment of our imagination, being as much a work of deranged jewellery as art, as much a symbol of excess as it is the physical embodiment of ostentation. The rumours, divisions and debates surrounding the skull have only added to its mystique (a group of Russian artists even staged a mock trial at which the prosecution argued it wasn't a work of art at all). It's a shallow world, ruled by mad markets and wealthy tyrants, the skull is telling me, but if you can't beat 'em, join 'em.

ELMGREEN & DRAGSET
THE COLLECTORS, *2009*

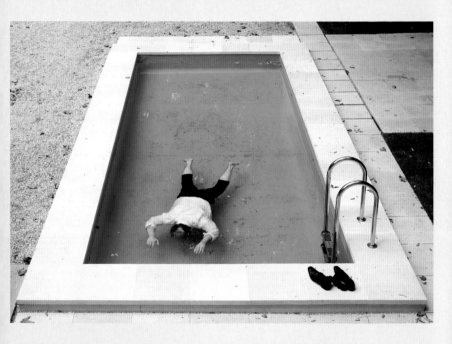

Contemporary art can be confusing. I've been wandering around two homes owned by a recently divorced pair of art collectors, or so the man claiming to be Roger the property broker tells me, but something is clearly not right with this picture. His brief tour of the first villa, which has a 'For Sale' sign outside, skirts over the fact that 'I Will Never See You Again!' has been scrawled on the hallway mirror and the enormous lacquered dining table has been crudely broken into his and hers halves, as has all the crockery. Roger refers to the gold statue wearing a uniform and pinafore, noting nonchalantly: 'The original maid died in the 1930s and has been preserved.' He points to the opposite corner: 'They also had the terrier stuffed.' The kid's bedroom is similarly suspicious, its bunk bed having been horribly charred and a swinging axe having been attached menacingly by rope to the wall. I lose Roger the realtor, but next-door's open house is even weirder, as semi-clad young boys lounge in an open-plan modern glass interior, watching TV or listening to music. Outside I'm stopped in my tracks, as the homeowner, presumably the neighbour of the ex-husband who has been rumoured to be his illicit gay lover, appears to be lying dead, bobbing face down in his own swimming pool.

'BURSTING INTO THESE PARALLEL UNIVERSES CAN FEEL LIKE INTRUDING ON A SOAP OPERA OR A REALITY TV SHOW, BUT UNLIKE THOSE VOYEURISTIC VIGNETTES OF LIVES LESS FORTUNATE OR RELATIONSHIPS MORE DYSFUNCTIONAL THAN OURS, EACH ENVIRONMENT REFLECTS BACK ON THE VIEWER'S OWN PREJUDICES OR PHILOSOPHIES'

Being that these two spaces are normally the Nordic and Danish pavilions of the Venice Biennale, I'm well aware that this isn't the set of the latest Scandinavian crime series, but a cleverly orchestrated bit of theatrical installation art by the subversive duo known by their surnames as Elmgreen & Dragset. From the elaborately envisioned domestic drama of *The Collectors* to an encounter with high fashion in the desert for their roadside shop-window display *Prada Marfa* (2005), Michael Elmgreen and Ingar Dragset specialize in ambitious dioramas that blur art with artifice and what's real with the imaginary. They have also constructed an entire four-storey apartment block, a recently vacated nightclub, a hay-strewn barn, a New York subway station and a depressing waiting room in various museums and galleries around the globe, accompanying each scenario with its own backstory and often actual or at least lifelike but inanimate actors.

Bursting into Elmgreen & Dragset's parallel universes can feel like intruding on a soap

opera or a reality TV show, but unlike those intensely voyeuristic vignettes of lives less fortunate or relationships more dysfunctional than ours, each environment this double act creates is meant to reflect back on the viewer's own prejudices or philosophies. As alien as a rich collector's home, a gay disco, a Prada store or a housing estate might variously be to us, they are windows into worlds every bit as complex and involving as our own, as well as neat critiques of the spaces and societies they inhabit. Standing next to a mannequin floating in a fake pool, after a chat with an ersatz estate agent in an obviously simulated exhibition experience, I'm struck by the shallowness of the assembled art world – the collectors, the artists, the curators and the critics wandering through these pavilions – and their often too-brief engagement with deeper narratives or complex ideas. Don't they realize this is ridiculing them too? Or do they think it's really real?

Fiona Banner, <u>Harrier</u>,
2010, BAe Sea Harrier
aircraft, paint, 7.6 x 14.2 x
3.71 m

ART AS SPECTACLE

'THERE WERE FOR ME NO MIGHTY
SPECTACLES SAVE THOSE WHICH I KNEW
TO BE NOT ARTIFICIALLY COMPOSED FOR
MY ENTERTAINMENT, BUT NECESSARY
AND UNALTERABLE – THE BEAUTY OF
LANDSCAPES OR OF GREAT WORKS OF ART.'

MARCEL PROUST, REMEMBRANCE OF THINGS PAST, 1922

So much of contemporary art is spectacular: it moves, it lights up, it astounds; it envelops us, it suck us in or simply dwarfs us. We expect to be seduced, enthralled and even overwhelmed by creations of ever-greater size, value, ambition and extravagance, with artists scaling up and pushing their work further, following the maxim of multiply, magnify, maximize!

The consumption of this category of art often involves very little looking at all, which is ironic given the sight-related meaning of the word 'spectacle'. Instead, it's invariably about the size, the destination or the sensationalism attached to each project. The impetus to catch the latest blockbuster work or most-talked-about art attraction is just as likely to be due to its physical draw as to any aesthetic pull – the result is often a visceral, rather than a visual, encounter. Even if there's no human, performative element promised to us (as was the case in Chapter 4), our bodily interactions with these ever-more staggering objects of contemporary art are becoming of paramount importance, even to the point of shaping all of our memories of art as experiences instead of images or concepts. We stand in awe, but barely see.

Art has always aimed to astound, inspire and assault the senses, so today's monumental, multifaceted statement pieces are only

Subodh Gupta, <u>Line of Control</u>, 2008, stainless-steel and steel structure, stainless-steel utensils, 10 x 10 x 10 m

the latest in a long line of crowd-pullers and gallery-pleasers. Yet, without really studying these gigantic or good-looking offerings, we cannot hope to get beyond superficial first impressions or the initial jaw-drop. Just because something is shiny and impressive, it doesn't mean there isn't a nuanced subject matter lurking under the surface. For instance, Fiona Banner's installation of two fighter jets, *Harrier* and *Jaguar*, in the central nave of Tate Britain in 2010, was at once a celebration of their sleek, sculptural forms and majestic scale (both shorn of war paint and then either presented in a mirror-reflective, polished-chrome state or with realistic feathers delicately added to its fuselage and wings), as well as a reminder of their inherent danger and violent, militaristic intent. An enormous silver mushroom cloud that erupted in the same atrium two years earlier, a work entitled *Line of Control* by Indian artist Subodh Gupta, might have been sending a similar message about the counterintuitively seductive and spectacular nature of conflict, were it not for the tiny component parts – stainless-steel tiffin tins or lunchboxes; domestic pots, pans and kitchen utensils – that made up this apocalyptic vision. The negative force of Gupta's exploding pillar was confounded by its aggregation of everyday objects devoted

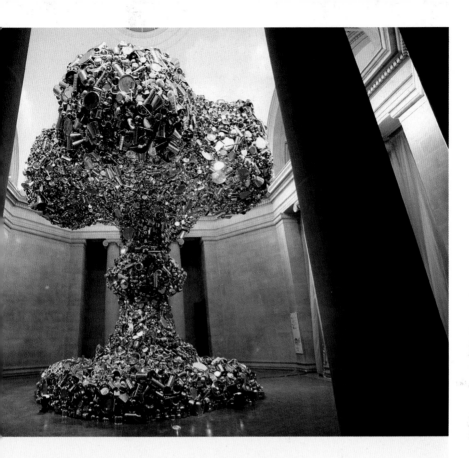

to nourishment and productivity – raining down a cloud of positivity and possibility rather than ash and destruction.

There is undoubtedly scope for subtlety after the initial impact of much spectacular art: I will deal with the troubling trend for artistic one-upmanship and for enormity, brio and braggadocio (especially in sculpture) after considering a work of sheer, ravishing ocular intensity that offers a very pure definition of art as spectacle. Not that you would know what was in store for you when approaching the tattered low-rise housing estate that hosted the immersive installation *Seizure*, first shown in 2008. Taking a single-storey property that was due for demolition, British artist Roger Hiorns filled it with a heated copper-sulphate solution that was then drained after slowly cooling and drying out, leaving behind a stunning interior of sharp, solid blue crystals inside. This ravishingly coloured compound had coated – or, more literally, seized – the inside of the building. Much as Hiorns stripped this apartment back to its essence before building it back up anew, I will discuss *Seizure* using my own alchemical formula, the *tabula rasa* principle, and start, as it were, from the ground up.

Roger Hiorns, <u>Seizure</u>,
2009

CRYSTAL METHODOLOGY

T STANDS FOR TIME. Before, during and after my first visit to
Seizure I was struck by all kinds of facts, figures and references to
time, quantity and temperature. The 90,000 litres (roughly a
swimming pool's worth) of copper-sulphate solution were heated
with water to 80 degrees Celsius in fifteen stainless-steel tanks
on site. The toxic mixture was then introduced into a specially
built structure that encased the entire apartment and was left for
over two and a half weeks, by which time crystals had formed,
settled and hardened on every available surface of the former
abode, including its bath and light fittings. For this to occur, of
course, a whole year of planning was required beforehand, as well
as a decade of previous experimentation with the technique by
Hiorns. After all that waiting, I only spent some fifteen minutes
inside on my first visit, but was immediately transported in
imagination to an ancient cave and then to some futuristic alien
terrain and back again.

A IS FOR ASSOCIATION. Apart from the last two reference
points, I can tell you what else crossed my mind while walking
through the glinting interior. It was like being submerged under
water, entering a sparkly nightclub or else staring up at the
ceiling of a darkened astronomical observatory. There were no
windows, the ceilings were low and the rooms tiny, so it felt
alternately prison-like and as though the world had been shrunk
to *Alice in Wonderland* proportions. The protective gloves and
boots I was wearing reminded me that this was also a hazardous
material and that the whole enterprise was essentially a risky
chemistry experiment writ large, although looking back across
the jewel-encrusted hallway towards the front door reminded me
that Hiorns had in fact been a postman, not a scientist, before
becoming an artist.

B IS FOR BACKGROUND. The choice of an unassuming
structure at 151–89 Harper Road, in the run-down, inner-city
neighbourhood of Elephant and Castle, London, was not
accidental, although the homes there were derelict and the land
already earmarked for redevelopment. For Hiorns, it represented
a chance to explore his private passion for London's Modernist
mass-housing programme of the 1960s, in which high-rise
towerblocks and futuristic residential complexes were meant to

create open and harmonious living spaces and 'streets in the sky'. However, such estates soon came to be maligned and were branded with the term 'Brutalism', which not only referred to the angular style of brick and concrete architecture predominantly employed at the time, but could be used to describe the often harsh living conditions and social problems that the apartment blocks had been intended to solve in the first place. As such, many ended up as 'slums in the sky'. One of the most notorious of these, the Aylesbury Estate, built in 1970 around the corner from Harper Road, was also being prepared to be demolished, but Hiorns managed to capture – if not exactly preserve or save – only a single structure among all the many such idealistic habitation units as an example of an admirable, if ultimately failed, utopian project.

U IS FOR UNDERSTANDING. Grasping a work as complex as *Seizure* through the lens of spectacle alone is impossible, because although it glitters and pleases the eye at every turn, it is also an oppressive and menacing space, whether you submerge yourself or explore its cramped confines tentatively, filled as it is with the ghosts of domestic drudgery and the realities of life in a squalid housing scheme. Furthermore, as an artist, Hiorns isn't himself especially prone to making overtly spectacular work: his sculptures since 2009 have largely consisted of barely noticeable drifts of fine particles, obtained by atomizing (basically pulverizing to a powder) such vastly differing objects as a jet engine and a stone church altar. At its most basic level, *Seizure* confronts our purely visual responses to beauty in art by surrounding the walls, and our bodies inside those walls, with a material so strange and bewildering as to make us question the encounter and even our very existence within its flickering azure boundaries. This rupture between seeing, feeling and being is at the core of much recent spectacular art and seems to require some form of extrasensory perception. Maybe I need to have another look...

L IS FOR LOOK AGAIN. Since my first visits to *Seizure* in 2008 and 2009, the housing estate it stood on has been flattened, but the entire crystalline apartment, all 31 tonnes of it, was itself, paradoxically, saved for the nation by the Arts Council of England. The grotto, moved in one piece up to the Yorkshire Sculpture Park on the back of a low-loader, has been transplanted

from its previously grotty surroundings to a new home surrounded by bucolic, verdant fields, in the company of other spectacular outdoor sculptures by the likes of Henry Moore and Sol LeWitt (although a suitably Brutalist cladding means it hasn't lost all of its connection to the concrete jungle it emerged from). Surrounded by the relative rural quietude of nature, however, and not the traffic-clogged streets and clamorous towerblocks of South London, *Seizure* will still dazzle those who enter, but is now an even stranger and lonelier place than before.

A IS FOR ASSESSMENT. Taking a piece of temporary public art such as *Seizure* and making it permanent in another context has undoubtedly changed its meaning, but hasn't necessarily dented its original ambition as a work of art. And while the aim of this book is to allow readers to come to their own conclusions about the successes or failures of certain works of contemporary art, I believe that the power of *Seizure* comes, not from its blue-tinted brilliance, but from its psychological resonances and after-images. As a rule of thumb I'd also say that, for a work to have any lasting impact on the psyche and not just the retina, the artist's vision has to stand prouder and taller than the structure that has been created to house it.

XXL

Spectacular art can appear in many shapes and sizes, but mostly it comes in large or extra-large. The American artist Richard Serra is certainly one of the last half-century's leading exponents of monumental sculpture, yet even his stature as an artist cannot be reduced to the statement 'bigger equals better'. Prior to the opening of a 2008 show of recent works such as *Open Ended* and *TTI London* (which stands for 'Torqued Torus Inversion') at the Gagosian Gallery, I interviewed him about his work and discovered that, surprisingly, monumentality wasn't very high on his agenda. Lines, forms, voids and various technical aspects of the steelmaking process obviously fascinated him and he told me about how the uneven floors and dome of a wonkily built church in Rome had recently put him off-balance in an interesting way. He even succinctly summed up his own work as being about 'the duration of the bodily movement through space and how one understands those sensations and experiences'. Indeed, despite the bulk and weight of his 10- and 20-metre-long expanses of

Richard Serra, <u>TTI London</u>, 2008, weatherproof steel

steel on display in London, the experience of walking round or through them felt incredibly fluid, with the machined surfaces seeming to bend inwards and sway outwards like reeds in the wind or else shoot up like sheer cliff faces, while also inviting me inside with an increasingly claustrophobic tightening of the air in my lungs.

The British artist Mike Nelson is another sculptor of the kind of art that is often too large to look at as a whole, but which requires the viewer's presence and exploration to make sense of its scale and ideas. Unlike Serra, Nelson is no maker of mega-monoliths, but an architect of interior space, an interventionist and a destroyer of neat, white-cubed galleries. For meandering installation works such as *Coral Reef* (2000) and *I, Impostor* (2011), Nelson reconfigured the innards of previously pristine buildings with passageways and chambers made from wood, brick and cement render to the point where the viewer was transported to a seemingly foreign or alien location, perhaps impinging on someone else's territory. His rooms are left eerily empty of life, but remain full of suggestive objects that are pregnant with dark possibilities – feeling simultaneously as though the corridors, crawl-spaces and rooms-within-rooms had been recently vacated or else were waiting for the inhabitants to return. Nelson's abandoned minicab offices with their menacing grilles, his red-tinted darkrooms and dusty, dishevelled workshops may not be spectacular in the grand manner of many oversized contemporary art monuments, but are nevertheless engrossing, interactive and all-encompassing environments designed to disorientate and disturb. They move us by means other than sheer size, namely by blocking out all external references to reality and creating reality anew (like a great novel) and by constructing rooms that invigorate the senses (like a great architect), albeit by confounding our expectations of a work of art through the deployment of confusing corridors and panic-inducing labyrinths.

LAND OF PLENTY

Even the more modestly scaled works of art that come as welcome antidotes to the enormity of public mega-sculpture can be spectacular and exhilarating to behold. Away from the well-trammelled international sites of art pilgrimage I've visited

Mike Nelson, I, Impostor,
UK Pavilion, Venice
Biennale, 2011

Rirkrit Tiravanija,
The Land, 1998–present

– the military compounds converted into hangars of Minimalist
art by Donald Judd in Marfa, Texas; the earthworks by Walter De
Maria and Robert Smithson in New Mexico and Utah; the
Japanese art island of Naoshima, and so on – none has left a
lasting effect to match that of the small plot of rice paddies in a
northerly Thai province near Chang Mai simply titled *The Land*.
This collaborative effort to farm and manage a smallholding of
animals, crops and self-sustainable energy sources, initiated by

Thai-born artists Rirkrit Tiravanija and Kamin Lertchaiprasert in
1998, has since seen colleagues such as Tobias Rehberger and
Philippe Parreno invited to add structures or systems to help
maintain or improve the environment there. On my arrival in
2005, I wasn't greeted by anything grander than some water
buffalo grazing, a few vegetable patches, some interesting-looking
shelters, and a mess of pipes and chambers designed to turn cow
dung into bio-gas for energy to run the site's electricity. Yet it was

Do Ho Suh, Bridging
Home, 2010

the notion that artists might work together for useful ends and social togetherness, and not for purposes of exhibition, recognition or sale, that bowled me over and gave me hope, not just for the truly immense potential of *The Land*, but for the future of contemporary art.

VERY SIMILAR, WITH ATTITUDE

As this remote outpost of communal art production in rural Thailand proves, it's difficult to escape the ubiquity of contemporary art these days. In parallel with the super-sizing of the art objects themselves, the exponential expansion of the supporting art world beyond the capital cities of New York, Paris and London means that the next valid artistic statement could come from anywhere across the world and might now be able to function equally well wherever it surfaces. The strange vista of a traditional Korean house wedged between two buildings in an alleyway in Liverpool in 2010, as if crash-landed from space, encapsulated this recent globalization of art practice as well as the cultural displacement of the artist responsible, Do-Ho Suh, whose upbringing in Seoul was interrupted when he was transplanted to finish his studies in New York. Suh's scaled-down version of his childhood domicile stranded on the other side of the planet (titled *Bridging Home*) was as surprising and as alien a spectacle as I could have hoped to see walking down the street, yet it also spoke to me of the invisible migrant populations living everywhere around me.

Just as spectacular art can contain unexpected subtlety, meaning, purpose and complexity, so our mundane, everyday lives and experiences can also be transformed or elevated to the status of spectacle – through the intervention of an artist, of course. In 2011 I received an invitation to the *Piccadilly Community Centre*, whose website offered (indeed, it still exists online) a variety of exercise classes, coffee mornings, drop-in singing lessons and instructional sessions on knitting or baking. I recognized the venue's address as the flagship space of a high-end art gallery and suspected the cleverly choreographed and outwardly credible community centre to be the work of one of its artists, the Swiss installation specialist Christoph Büchel, none of which was confirmed or denied by the associated press releases. Despite trying too hard to hide his hand behind numerous layers of

deception, Büchel's *Piccadilly Community Centre* worked on many levels, not least because the gallery's four floors were packed with activity, from a basement bar and disco to an internet café and money-transfer service on the ground floor, to the dance and music rooms on the first first and a charity store on the top floor (there were also secret crawlspaces, walkways and an anarchist's garret in the attic). The clash between reality and art was uncomfortable at times, especially when it involved participants ostensibly attending classes but also unwittingly playing roles within an elaborate artistic game, but the underlying assertions – that normality could be rendered fantastic and that everything might be art when looked at from a certain angle – were magnificently explored, perhaps simultaneously, in the most and least spectacular ways imaginable.

Christoph Büchel,
Piccadilly Community
Centre, 2011

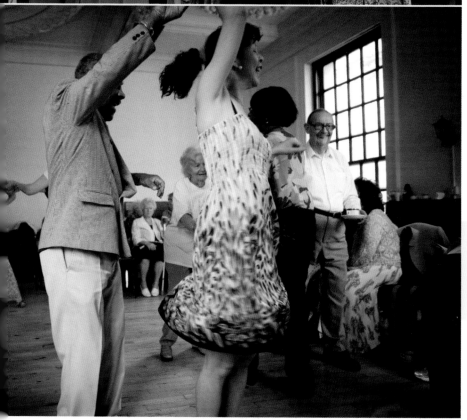

TOMÁS SARACENO
CLOUD CITY, *2012*

Perching on the roof of perhaps the world's most august and prestigious art institution, the Metropolitan Museum of Art in New York, is a clutch of sixteen conjoined room-sized pods, made up of interlocking pentagons and hexagons, which offer a panoramic, polygonal playground for adults and big kids like me to explore. Clambering through each chamber, I catch sight of the Manhattan skyline or the expanses of Central Park in the many mirrored surfaces and find myself getting caught up in knots in black cord webs. Occasionally the floor seems to give way, but happily there is clear acrylic stopping me from dropping into the module below, although it can still be hard to know which way is up or down when the sky is reflected beneath me and the museum's terrace seemingly hovers overhead.

The Argentinian interdisciplinary artist, architect, engineer, dreamer and schemer Tomás Saraceno has long been trying to achieve weightless works of art and airborne architecture (it might be better described as artiteture or sculpitecture given that these are generally temporary, uninhabitable structures). He has given audiences the feel of floating free from gravity in bubble-like spheres, mimicked the sensation of flying on giant inflatable pillows and let them skywalk across transparent waves of plastic sheeting. For *On Space Time Foam* in Milan in 2012, he suspended gallery-goers 24 metres over a hangar-like space with only three layers of PVC membrane between them and the floor, while every step or movement caused ripples and imbalances elsewhere in the installation.

Saraceno's stated aims include the creation of ecologically sustainable, nomadic 'Cloud Cities' or 'Air-Port-Cities', housing aerial populations that might rise above national concerns or earthbound social interests. What might seem like architectural impossibilities left over from the 1960s or impractical sci-fi solutions to living on solid ground, however, are slowly becoming science-fact, given that Saraceno is experimenting with such hi-tech and cutting-edge materials as Aerogel, a substance made up nearly entirely of air and that is normally used by NASA to coat its spacecraft. He is also planning a biosphere that will hover above the Maldive Islands, constructed from solar-powered air balloons, like the continuously expanding one he is creating from recycled plastic bags (titled *Museo Aero Solar*, begun in 2008 and still ongoing).

His investigations into space and the fabric of the universe have also led him to create an exact replica of a black widow spider's web, only enlarged sixteen times to human scale. Its crisscrossing networks and lines of interaction chime with theories of how the cosmos began and how everything is knitted together, again demonstrating how art can productively collide with astrophysics, architecture or aeronautics. Whether Saraceno's ideas could eventually better our environment and declutter our

'HE HAS GIVEN AUDIENCES THE FEEL OF
FLOATING FREE FROM GRAVITY IN BUBBLE-LIKE
SPHERES, MIMICKED THE SENSATION OF FLYING
ON GIANT INFLATABLE PILLOWS AND LET THEM
SKYWALK ACROSS TRANSPARENT WAVES OF
PLASTIC SHEETING'

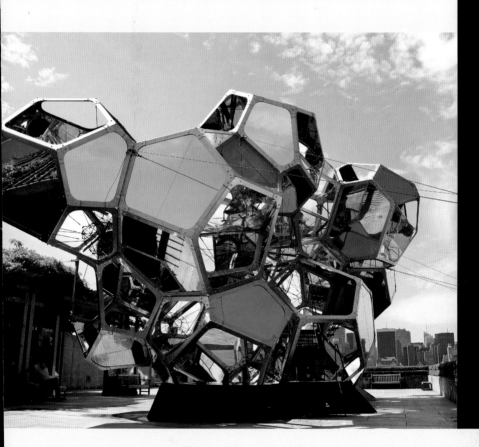

own tangled webs of urban life might be
down to how seriously he is taken, either as
an artist or an architect. After all, utopians
and visionaries throughout history have
often been treated like madmen, so there
has clearly always been a fine line between
what's deemed pure fantasy, a bit of fun
and a glimpse of the future.

URS FISCHER
YOU, *2007*

When you enter a commercial art gallery you usually expect to find clean, white walls and a number of objects or pictures for sale. In 2007 the Swiss sculptor Urs Fischer seemingly broke all those rules by hiring a team of contractors to dig up most of the floor of the normally pristine space of the New York-based gallery Gavin Brown's Enterprise, leaving nothing but a precarious walkway around a deep, rubble-strewn hole in the ground. Resembling a battlefield or a construction pit rather than an exhibition, Fischer's destructive, anti-artistic statement was not only an assault on the senses – involving as it did a precipitous 8-foot drop and the risk of serious injury – but it was also an attack on the very structures that support and validate art itself (it was nevertheless sold to a foundation for excavation at a later date at some other location).

Fischer's fittingly imperative-interrogative title, *you*, also echoed the idea of a personal challenge or an insult, suggesting that the viewer was unflatteringly reflected in the crater's barren emptiness or might somehow be to blame for the mess. I always find it a particular challenge to write or think about a work I haven't seen first hand, as is the case with Fischer's notorious intervention, but that doesn't necessarily mean it's an impossible task. Images of *you* immediately conjured up memories of two immersive works I had been fortunate enough to experience that same year, commissioned by the German town of Münster for an exhibition of ambitious outdoor sculptures

held there once a decade. The first of these two other giant holes submerged below ground level was by a leading figure of American conceptual art, Bruce Nauman, and involved standing at the centre of an enormous sunken plaza, at which point your eye-line was restricted to nothing but the concrete surrounding you. Entitled *Square Depression*, it was a while before I figured out that I was standing, literally, six feet under. The second was called *Archaeological Site (A Sorry Installation)* by a Belgian artist, Guillaume Bijl, for which an enormous square section of parkland had been excavated to reveal the sunken spire of a church, its weathervane reaching to only a few feet below the Earth's surface.

Although all these projects relate back to common ideas about ancient art, architecture and archaeology, they are also recent examples of the predominantly 1960s phenomenon of Land Art, for which artists used the outside world as their material and arena for making sculpture. The main difference is that, nowadays, the urban fabric of our environment is increasingly subsuming the natural landscape and so few artists look beyond the cities for their inspiration or subject matter. When Robert Smithson, perhaps the most famous Land artist, responsible for building the *Spiral Jetty* out of rocks and salt crystals in 1970, wrote that 'museums and parks are graveyards above the ground', he could well have been describing the topsy-turvy acts of artistic violence and cultural vandalism being done

'RESEMBLING A BATTLEFIELD OR CONSTRUCTION PIT, FISCHER'S DESTRUCTIVE STATEMENT WAS NOT ONLY AN ASSAULT ON THE SENSES BUT AN ATTACK ON THE VERY STRUCTURES THAT SUPPORT AND VALIDATE ART ITSELF'

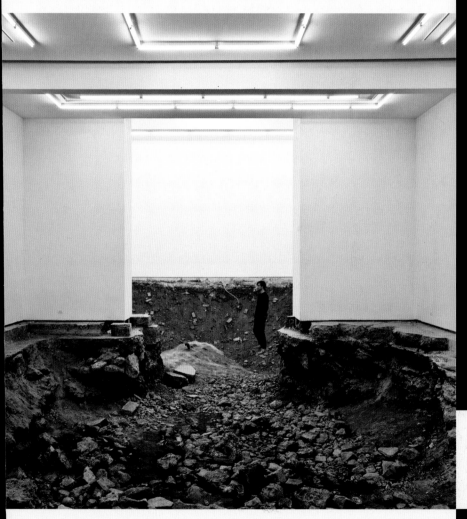

thirty-five years later by Fischer, Nauman and Bijl (let's call them exponents of a new artistic underground). These openings are reminders not just to look up or in front of you, but also to see what lies below and beneath.

ART AS MEDITATION

'IF SOMETHING IS BORING AFTER TWO
MINUTES, TRY IT FOR FOUR. IF STILL
BORING, THEN TRY IT FOR EIGHT, SIXTEEN,
THIRTY-TWO AND SO ON. EVENTUALLY ONE
DISCOVERS THAT IT'S NOT BORING AT ALL.'

JOHN CAGE, FOUR STATEMENTS ON THE DANCE, 1944

It's not rude to stare at art. Quite the opposite, in fact: it's the least you can do. Stop. Breathe. Relax. Don't think, just look, take it all in. Soak up your surroundings, feel the space in front of you, set your mind free, let your internal monologue recede and allow your eyes to settle. When was it that you last allowed yourself such a moment? Well, as an art critic, it's been my full-time job to peruse beauty and pontificate on complexity, but even I have struggled to slow down my appreciation of art.

Certainly, as one of a tiny band of writers more or less paid just to attend exhibitions, the pressure to see more of them, to look more quickly and review them faster, has grown in line with the pace of rolling news feeds now favoured by most publishing outlets and the immediacy of the voracious, neophiliac handheld media device. Also, what with the proliferation of disorienting multi-screen video rooms, athletes sprinting through galleries, fragmented visual codes and hyperreal technologies to contend with at the exhibitions themselves, it can seem like speed is of the essence in contemporary art. Indeed, this book is itself based on a process of efficient and effective art consumption, an easy-to-apply technique that tries to drag out some discernible sense or enjoyment from the most baffling or elaborate of art experiences, without first having to ingest the assembled back catalogues of art history,

Mariko Mori, <u>White Hole</u>,
2012, acrylic, LED lights,
239.2 x 272.2 x 65.3 cm,
private collection

Below: Mariko Mori,
<u>White Hole</u>, 2012,
installation view

philosophy, cultural theory and critical consensus. We want meaningful experiences and discoveries, and we want them now!

And yet... There are artworks that demand contemplation, which need to be patiently absorbed, ingested, inhaled. At the risk of sounding like some cult hippy tract or a self-hypnosis manual, an extended encounter with such pieces can induce calm, reduce anxiety, lift the spirits and expand consciousness. The manipulation of natural and electric light sources by the American artist James Turrell provides an antidote or salve to the noise of the outside world, encouraging you to block out the wall texts, the pamphlet handouts, the catalogue or the peripheral chatter of the gallery and to just *be*. His experience growing up as a Quaker, and studying mathematics, astronomy and psychology, has undoubtedly influenced Turrell's meditative approach to making art that deals with the intangible or the incomprehensible. I've spent many hours gazing up at the heavens in his 'Skyspace' rooms, with the ceilings cut out to reveal the bright firmament up above, or else sat in one of his hazy fields of light, considering nothing more than the properties of colour and thin air. I've been enclosed in one of his strobing, kaleidoscopic light immersion tanks or 'Perceptual Cells' (the one I tried was called *Bindu Shards* of 2010), designed to stimulate electromagnetic impulses in the brain and induce a higher state of awareness – even though my immediate reaction to the pulsing sensorial bombardment was one of claustrophobic panic. The point came when I either had to push the emergency stop button or submit to the will of the machine and go with the flow.

Being a hardened cynic by profession, it can often take a momentous leap of faith for me to let my guard down in this manner, as it did when I was pulled through a fallopian corridor into the womblike chamber of *White Hole* (2012), created by Mariko Mori, a Japanese artist whose futuristic space pods and Buddhist-inspired, Zen-like sculptures had always filled me with a dread of their cod-religious, pearlescent slickness rather than with the blush of spiritual uplift they were designed to inspire. However, as a luminous glow of fibre optics swirled in front of me, ostensibly depicting the creation of a new star, I couldn't help but be moved by the connection I felt to this amoebic blob of light behind a frosty dome, willing it to be born. Call it enlightenment or the soft-headedness of parenthood, either way I

ed and felt the momentary
ome after the sustained, long look.

E THE SEASIDE

n or changes of heart require time. They
selves, to create an atmosphere, to warp
naybe – to formulate a new universe.
a *tabula rasa* methodology starts – once
clean or whitewashed the canvas, that is
he. The importance of a work can mature
ven if the original encounter doesn't eat
cious hours on the planet. Walking
English seaside town and blindly
econd Folkestone Triennial in 2011, I
ten sculptures by the artist Ruth Ewan,

which had been installed in locations somewhere among the cobbled streets, fish-and-chip eateries and harbour walls. Eventually I spied one of her doctored clock faces above a department store, the only clear difference being that Ewan had decimalized each of her public timepieces to show only ten hourly intervals in place of the usual twelve. Her idea derived from the short-lived adoption of a new metric system after the French Revolution of 1793, which included the Republican calendar, made up of 100 seconds, 100 minutes, 10 hours and so on. Though it lasted, ironically, little more than a dozen years, until 1805, 'Revolutionary Time' represented a radical, but ultimately unworkable break with tradition, much as Ewan's small attempts to distort the logic and patterns of a whole town went largely unheeded by the blissfully ignorant passers-by of Folkestone – a metaphor, perhaps, for the artist's often thankless mission to fundamentally change the way we see things.

Except I then discovered more of Ewan's simplified timekeeping devices in the hours that followed; they were hanging above an old hotel frontage, tucked away on a bookshop shelf or kept behind the bar in a local pub (apparently there was even one in a taxi). The infectious insistence of Ewan's project, collectively titled *We Could Have Been Anything That We Wanted to Be*, washed over me and seeped into the world as a possibility, however remote, for real revolution. Whether or not anyone else had noticed didn't matter – it had activated my thoughts and set something in motion, like the march of time itself.

This kind of contemplative situation, or 'Art as Meditation', as I've called it, is not about conceptual art, or anything necessarily related to the 1960s Conceptual art movement (with a capital C). Nor is it about seeing something that isn't there or posing more thoughts that can only live in your head. It relates to the ability to better appreciate or more deeply engage with a work of art without succumbing to the bite-size nibbles of culture offered elsewhere or having our heads turned this way or that by any number of other tempting distractions. Certainly, after seeking out Ewan's decimal clocks, I took more notice of the immediate environs of Folkestone, finding pleasure too in locating other interventions by Tracey Emin, who had left bronze casts of children's socks, shoes and gloves (*Baby Things*, 2008) strewn about the place, as well as the wonderful colour wheel and bluish

Tracey Emin,
<u>Baby Things</u>, 2008,
patinated bronze,
dimensions variable

flags (*The Colour of Water*, 2011) by Spencer Finch, which allowed me to compare 100 different hues in the hunt for one that would match the sea as it appeared at that time of day. At a certain point I felt as though I didn't have to look for the art any more, that instead it would find me.

PERFUMED ROOMS

The first A in my *tabula rasa* formula stands for Association rather than Appreciation, but who is to say that we can't relate to art through different environmental factors or using senses other than sight? When was the last time you stopped to smell a work of art? The aromas wafting from the often heavily scented work of Scottish sculptor Karla Black can reinforce stereotypes of gender, domesticity and what could be deemed 'womanly' materials, given that she uses pastel-shaded powders, soaps and cosmetics including fake tan, lipstick, deodorant, nail polish, body lotion and toothpaste. But, for me, their smells recall not so much femininity as department stores, family shopping trips, luxuriant baths and perfumed teenage bedrooms – olfactory associations so far removed from the context of art exhibitions as

Karla Black, <u>Scotland in Venice</u>, installation view, Palazzo Pisani (S. Marina), Venice Biennale, 2011

to give Black's evocative abstract sculptures a real worldly relevance. The aesthetic pleasure of her mounds of chalk, earth and crushed bath bombs, coupled with hanging veils of cellophane or sugar paper, is also at odds with most macho, solid, on-the-floor sculpture, giving her work an organic lightness, added optimism and playful exuberance.

NEVER-ENDING STORY

If there's time to smell the roses (metaphorically), then I'm prepared to go back on one of my own rules and spend at least a few minutes reading and boning up on some B for Background. While I'm still adamant that there's no need to rehash or recap the history of modernity every time you are faced by a work of contemporary art, there are those instances when a text that accompanies or – as in the case of Dora García's *All the Stories* (2011) – forms the major part of the work is vitally important. Very often García's medium is the written word or at least the written instruction performed as an event, but for this ongoing project she is attempting to gather every imaginable story into a never-ending ark or Domesday Book-like anthology of all possible plotlines. García initially gathered these short-form narratives, usually four sentences or less, over a period of ten years for a book, which includes some 2,500 examples including such pithy one-liners as 'As a hurricane approaches, two men confront each other' and 'A young man breaks into the magnificent villas of extremely rich people not to steal, but to pretend, for as long as he can, to be one of them'.

While her overarching idea can also be distilled into a similarly terse 'elevator pitch' – to use the parlance of television and film that García's brief vignettes are so clearly indebted to – the more one reads of them (now also spilling over into a website that can be updated indefinitely), the more they open up the possibility of an endless repository of stories that is yet to be uncovered. As well as being teasers to the longer anecdotes, film scripts, novels, historical events and newspaper stories that many of García's pages are drawn from, it's the very act of ingesting even such tiny tales that is rewarding over a long period of time. In contrast to our proclivity for condensing culture down to bitesize morsels, which García's work knowingly does, her project also allows for a breadth and continuity that outstrips our need for newness and

Delinquent children on an uninhabited island have to take each other on in a life and death struggle.

A bunch of kids, bored with sex and drugs, turn to murder.

A plane lands at an airport but one of the passengers is not allowed to enter the country; neither is he authorised to return home. The man stays in the airport for eleven years.

A book which every time you open it seems to have a different number of pages.

A man keeps a turtle as a pet but dislikes the pattern of its shell; he decides to have it covered with gold leaf and precious stones. Shortly after the turtle dies but the shell remains.

A man whose time runs backwards.

A man is only allowed to say one word. Sometimes, the word seems to somehow fit in a certain conversation, then he says it. When not, he remains silent.

An angel visits a young maiden to announce to her an extraordinary event.

A man called Number One informs another man called Number Six that he is just a number, but precisely because of that he will be happy for the rest of his life. Number Six does not seem too overjoyed with the news.

A man called Thursday must attend an important meeting with other six men, called Monday, Tuesday, Wednesday, Friday, Saturday and Sunday. Sunday behaves as the self-proclaimed leader of the band.

Dora García, <u>All the Stories</u>, 2011

Walead Beshty, <u>20-Inch Copper (FedEx® Large Kraft Box® 2005 FEDEX 330508) International Priority, Los Angeles-London trk#8685 8772 8040, Date October 2–6, 2009, International Priority London-New York trk#863822956489, Date November 18–20, 2009</u>, polished copper, FedEx shipping labels

immediacy. Hers is an impossible endeavour, like trying to imagine the entirety of the internet, but it's also a poetic statement akin to 'The Library of Babel' imagined by the Argentine author Jorge Luis Borges, in which every possible ordering of a few basic characters (twenty-two letters, spaces and punctuation marks) results in an unwieldy and unreadable archive of words.

FUGITIVE THINGS

Just as these little bits of background reading can go a long way towards positioning a work of art outside its immediate physical or conceptual parameters, so the act of stopping to think about or around an art object – where has it been, what does it do, where is it going? – can also expand its possibilities and aid in its wider Understanding. Thinking around the notion of the art object is encouraged by the processes and practices employed by Walead Beshty, whose photographs and sculptures go through different stages of manipulation, movement or manhandling before they arrive in a gallery, most of which have very little to do with the traditional touch of the artist, but rather with the many touches and intercessions of others. His most famous works are his globetrotting 'FedEx Boxes', pristine cubes or voids of glass or copper that are shipped to and from exhibitions by the international haulage company, with all the attendant labels, shipment dockets, signatures and packaging displayed alongside the objects that were transported with them. Beshty purposefully sends these works into harm's way on their journeys through customs, border controls and airports, and on forklift trucks, expecting them to become chipped, cracked and tarnished. Even though the glass is shatterproof and the copper durable, they are still fragile objects, easily damaged in transit or marked by fingerprints when unwrapped. These imperfections multiply with each plane voyage, boat crossing and museum installation, resulting in peripatetic works that brazenly show their scars and accrue the patina of age, just as a person might appear careworn by excessive travel or the passing of time.

Perhaps Beshty's fugitive objects argue that art cannot be judged on mere looks alone and should be scrutinized according to its context and history, which in his case would involve an update of the language and strategies of 1960s Minimalism to incorporate

David Claerbout, <u>White House</u>, 2006, single-channel widescreen video projection, colour, dual mono over headphones and speakers, 13 hours 27 mins 53 secs

our newly jetsetting, commercial merry-go-round of an art world. While this entirely valid interpretation would refute my contention that contemporary art can be appreciated, in the first instance, simply by starting with a clean slate and a set of simple guidelines, I would counter that any time spent looking at his boxes is rewarded with a similar proportion of enlightenment about Beshty's motives (if not his actual art-historical references), confirming my belief that the works are less concerned with the specific progress of the Minimalist artwork over the last forty years than with morphing each sculpture into a kind of amber, preserving traces of its movement through time and space. In other words, don't spend too much time worrying about someone else's intellectual theories when, to put it bluntly, nobody ever understood anything less by looking a little longer.

CHAPTER 8

DÉJÀ VIEW

Maybe I jumped the gun with that statement. Watching either of the two epic thirteen-hour videos, *Bordeaux Piece* (2004) and *White House* (2006), by Belgian artist David Claerbout for any length of time seems, on the contrary, to advance only misunderstanding. Despite their lengthy running times, the action in both films lasts only for ten minutes at a time, after which the actors and cameras return to repeat the entire scene from the beginning. In *Bordeaux Piece* we see an incestuous love triangle endlessly reprise its mundane mini-drama, while *White House* features two men locked in a fight to the death, again looped *ad infinitum*. Were you to sit there for a good while, or

Pierre Huyghe, <u>Untilled (Statue of Female Nude with Bee Colony)</u>, 2012, Documenta, Kassel

employ the L in the *tabula rasa* formula to Look Again (and again) at these slowly revealing montages, you might notice slight differences in each sequence and a subtle change in the light conditions. The artist evidently filmed these near-identical vignettes at ten-minute intervals throughout the day, with the first shoot taking place at dawn and the last sometime after dusk. Audiences need not sit through all of Claerbout's marathon viewing sessions, but the initial *déjà vu* we might get from watching the same clip over and over is soon disrupted by the revelation that we might be missing a grander narrative. I've found watching Claerbout's films to be the twenty-first-century equivalent of sitting in front of a landscape painting, where the surrounding ambience and atmospheric effects of light often take precedence over whatever is the central, visual focus of the picture.

Prolonged meditation or contemplation of any work of art should aid with our last hurdle, the final A for Assessment. But after stumbling on an intervention in the landscape of a German park, part of the 2012 edition of Documenta, an enormous exhibition held every five years in Kassel, no amount of reflection on this disturbing scenario could satisfy my critical faculties. The park's compost heap, hidden from the grand oak-lined avenue by a thicket of shrubs, had been turned into an amphitheatre, at the centre of which was a statue of a reclining woman whose head had been replaced by a bee colony. A skinny white dog circled around me, one of his legs painted shocking pink, while the rest of this dystopian ecosystem consisted of a basalt hillock, some pavement slabs and numerous exotic plants, including deadly nightshade, poisonous foxglove, poppies and an unmistakable sprouting of *cannabis sativa*. While all these haphazardly placed elements gave the impression of *ad hoc* happenstance, the foraging dogs and the mind-altering foliage seemed to form a constellation around the nucleus of the pollinating bees, as though I'd come across a ruin of the Garden of Eden after it had gone to seed and long ago dispensed with the troublesome existence of man. Contemporary artists, such as Pierre Huyghe, whose work *Untilled* I was lost in that day, often go out of their way to make audiences feel unhinged, unwelcome or just late to the party. Full disclosure wouldn't be half as much fun, though, given that the reward in art appreciation is clearly in the journey, not the arrival at some conclusive end-point.

GERHARD RICHTER
CAGE, *2006*

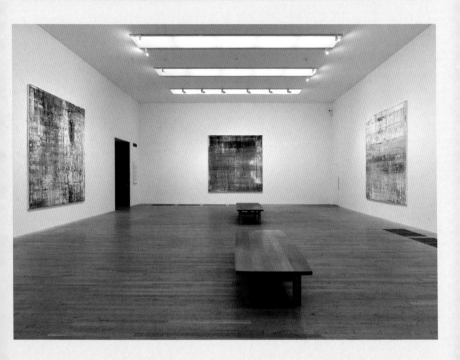

The six grey-greenish squares surrounding me could be snapshots of motion-blurred landscapes from the windows of a moving car, reflections shimmering and collapsing in pools of rippling water or indeed evocations of a metallic prison closing in on me from all sides, as their collective title, *Cage*, suggests. They are, in fact, a suite of oil paintings on canvas by the revered German artist Gerhard Richter, whose chosen medium and support were those traditionally ordained for the depiction of the grandest moments or figures throughout history.

Richter instead offers no recognition, no representation – nothing but indistinct haze and cloudy, squeegeed smears of colour. His scraped-back surfaces, revealing layer upon layer of paint, might, at a push, resemble bashed and beaten panels of car bodywork or close-ups of scarred airport runways. Such unrelentingly abstract work, which refutes all but the most tangential descriptions of anything in the real world, forces me to look for meaning elsewhere. As if to bar my way further, Richter titled these works *Cage 1*, *Cage 2* and so on, after the avant-garde composer John Cage, whose mantra was 'I have nothing to say and I'm saying it' and

whose Minimalist music the painter was apparently listening to while completing the series (Cage is famous for his piece *4'33''*, which consists of four minutes and thirty-three seconds of silence).

'AS IF TO BAR MY WAY FURTHER, RICHTER TITLED THESE WORKS *CAGE 1*, *CAGE 2* AND SO ON, AFTER THE AVANT-GARDE COMPOSER JOHN CAGE, WHOSE MANTRA WAS "I HAVE NOTHING TO SAY AND I'M SAYING IT"'

Faced with six pictorial and conceptual dead-ends, I change tack and start looking, and I mean really looking. Because merely observing, gazing or watching implies a passive act like skim reading or letting a camera pan across a scene without ever stopping to focus. Looking should be active, inquisitive. But as a verb, looking can also sound like an imperative – Hey, you, look at this! – and I believe art is meant to be an open, rather than a didactic experience, so other less forceful terms for appreciating abstraction might include imbibing, soaking up or subsuming. These works won't give up their secrets readily. They might only become apparent after persistent or repeat viewings, or they may suddenly appear in a flash and disappear again just as fast.

All of Richter's paintings deal with the problems of seeing and of remembering the past, as well as presenting new possibilities for ways of picturing or thinking about the present. The *Cage* series suggests that nothing we see can be trusted or fully understood, so we might as well revel in these oceans of anxiety that resolutely resist easy readings. Each successive layer of gesture and scraped-back paint is overlaid with the next swipe of his blurring, wiping tool (although each of these in-between moments is often the subject of a photograph, kept somewhere for posterity). These too, then, are history paintings, with hidden depths that lurk like geological substrata beneath the surfaces. Richter's panoramic and pan-historical approach to artistic investigation and the human experience makes him truly an artist for our age, and for the next.

REMBRANDT

SELF-PORTRAIT WITH TWO CIRCLES, *1661*

An ageing man stares at himself in the mirror in 1661; but what do we see, now? His brown housecoat speaks of hard times for his profession, represented by the brushes in his hand. Indeed, this Dutch painter's commissions were waning later in life, as was his fame, but these mere props don't tell the full story written on his furrowed face. This wonderful, dark self-portrait in which the artist's features are built up from layers of thick impasto, one on top of another, as if preserved in ancient amber, is by Rembrandt van Rijn and can be found at Kenwood House in London. Although it is perhaps less piercing than many of his other fifty or so self-portraits in oil, with the eyes soft and resigned to his impending fate, it is clearly an image of a man entering the final decade of his life (he died in 1669). Some say Rembrandt was losing his faculties in the solitary confinement of the studio and that his scrubby, uneven handling was a sign of a dwindling light. But this servant of art is still proudly working away (see the giant preparatory circles drawn behind him) and stands defiant in the face of impending death. Rembrandt has been called a truly modern artist and was one of the first to really explore self-portraiture, but it took him a lifetime to discover who he really was with this near-final picture.

While it might seem confusing to end a book on contemporary art with a painting that is over 350 years old, there is perhaps no better way to slow down and tabulate one's appreciation of art than by sitting

with one of the Old Masters. Contemporary art is undoubtedly faster in every way – not only in the amount of sheer Time needed to absorb it, but (to go through the TABULA acronym) in terms of how fast you can create an Association, research that Background, begin an Understanding, dispense with the double-take and Look again, before reaching your final Assessment. Contemporary art allows you to be quicker to judge what is right or wrong with it and consequently is itself quicker to be judged. But that doesn't mean that the old ways of looking are wrong.

'THERE IS PERHAPS NO BETTER WAY TO SLOW DOWN AND TABULATE ONE'S APPRECIATION OF ART THAN BY SITTING WITH ONE OF THE OLD MASTERS'

Every era has its own kind of art with its own individual time stamp, and needs a contemporary eye to make sense of it. In *Ways of Seeing*, John Berger views many historical canvases through a modern lens, discussing Rembrandt's self-portraits as advertisements of his financial status and emotional state, as well as revealing how futuristic the Dutch master's view of his own profession was and how much he changed painting in his lifetime. One example of how Rembrandt can be seen or skewed through contemporary eyes occurred recently when Google paid tribute to the artist, on his 407th birthday, with a Google Doodle, one of the internet search

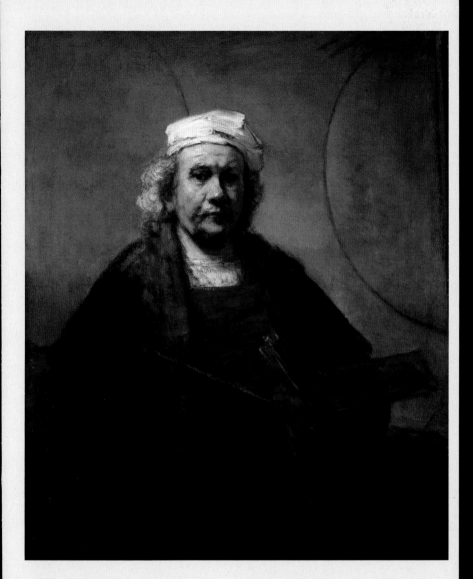

engine's homages to famous figures. Google's cartoonish illustration on its homepage depicted the same Kenwood House self-portrait, but replaced the mysterious circles behind him – often referred to as hemispheres, mathematical or Kabbalistic signs, but possibly just boastful examples of his ability to draw perfect circles – with the two 'o's of the word Google. Although in truth it was a horrible pastiche of a masterpiece, this simplistic, jokey reading of Rembrandt actually acknowledges that there are infinite possibilities in his work, or at the very least a googol (a number followed by 100 zeros) of different ways to read his work. There are also innumerable answers to all our questions about contemporary art and why our enjoyment and interpretation of any art, young or old, can come round full circle to enrich, inform and complicate our lives.

FURTHER READING

John Berger, *Ways of Seeing*, Penguin, 1972
Originally a pioneering television series, this slim volume proved no less radical when it came out soon after. Somewhat astonishingly, *Ways of Seeing* is still widely read as an influential and indispensable set text for art students more than forty years later. Apart from the quirks of style and presentation – the boldface type, the black-and-white images and the chapters without words – Berger's real skill was in enlightening and enlivening the experience of looking at some frankly awful reproductions of Old Master paintings, without resorting to academic language or needless overcomplication. As a touchstone for my book, the main similarity between the two projects seems to me to be in our common quest for accessibility, perhaps at the expense of scholarly rigour, and in an attempt to instigate new ways to look longer and harder.

Bruce Altshuler (ed.), *Biennials and Beyond: Exhibitions That Made Art History 1962–2002*, Phaidon Press, 2013
This primer to some of the best shows of the latter half of the twentieth century revisits such keys exhibitions as *When Attitudes Become Form* of 1969 and Documenta 11 of 2002, so you don't have to pretend to be old enough to have seen them. It is the sequel to a previous tome, *Salon to Biennial: Exhibitions That Made Art History 1863–1959* (Phaidon Press, 2008), which delves even further back in time to the first Impressionist salon, again so you don't have to.

Patricia Bickers and Andrew Wilson (eds), *Talking Art 1: Art Monthly Interviews with Artists since 1976*, Ridinghouse, 2013
Not quite in the league of the *Paris Review Interviews*, this is nevertheless an invaluable reference for no-nonsense discussions by many leading artists of the last forty years including David Hockney, Anthony Caro and Steve McQueen. While compiled from a catalogue of conversations published by a British art magazine, there are also international interviewees including the likes of Joseph Beuys, Barbara Kruger, Jasper Johns and Hans Haacke, not to mention a few of the artists included in this book such as Mike Nelson, Sophie Calle and Richard Serra – as well as a certain writer and critic by the name of John Berger.

Hans Ulrich Obrist, *Interviews* Volumes 1 & 2, Charta, 2003 & 2010
In the same vein are these two collections of question-and-answer sessions between renowned roving Swiss curator Obrist and some 150 artists, architects and thinkers from Daniel Buren and Ai Weiwei to Jacques Herzog and Richard Hamilton.

Documents of Contemporary Art, Whitechapel Gallery & MIT Press
This ongoing series of handy readers each covers a specific topic or theme in contemporary art, much like the categories I have split this book into. With over twenty-five titles available, ranging from *Time*, *Abstraction* and *Documentary* to *Dance*, *Education*, *Sound* and *The Sublime*, the aim should not be to collect the set, but to pick and choose the themes best suited to your tastes and pursue each book's potted reading lists and expertly curated excerpts.

Richard Kostelanetz, *A Dictionary of the Avant-Gardes*, Routledge, 2001
While I don't like or use most definition dictionaries, this one at least attempts a cross-cultural bridge taking in the disciplines of dance, theatre, literature and music, in addition to the main movements in recent art. This encompasses such decisive avant-garde moments from Abstract Expressionism and the Theatre of the Absurd to Vorticism and the Velvet Underground, stopping at almost everywhere else in between.

Paul Schimmel and Kristine Stiles (eds), *Out of Actions: Between Performance and the Object 1949–79*, MOCA & Thames and Hudson, 1998
Produced to coincide with an American touring show organized by the Museum of Contemporary Art in Los Angeles in 1998, this exhibition catalogue is still worth seeking out. In my view, it is perhaps the best reference work yet to be published on live art, providing an illuminating introduction to early performance art, its remnants, documentation and international spread.

Kristine Stiles and Peter Selz (eds), *Theories and Documents of Contemporary Art: A Sourcebook of Artists' Writings*, University of California Press, 1998
Often it pays to go straight to the horse's mouth, and this encyclopaedic gathering of writings and pronouncements by significant artists is a treasure trove of bons mots and key tracts in the development of contemporary art.

Carlos Basualdo and Calvin Tomkins (eds), *Dancing Around the Bride: Cage, Cunningham, Johns, Rauschenberg and Duchamp*, Philadelphia Museum of Art, 2012
Anyone looking to discover the enduring influence of Marcel Duchamp will find a wealth of material here relating to his importance for modern art, music, dance and thought. Centred around an exhibition of the same name, this catalogue doubles as an anthology of essays and articles by the likes of John Cage, Susan Sontag and Jasper Johns.

Michael Fried, *Art and Objecthood: Essays and Reviews*, University of Chicago Press, 1998
Despite specializing in nineteenth-century French and German art, this esteemed art historian took the newly emerging forms of minimalism to task in 1967, unwittingly creating a framework for much of the subsequent thinking around challenging or 'theatrical' modes of art. It's still relevant as a means to decoding much of today's more disparate and difficult works, but is heavy on the theory and philosophical underpinnings, so approach with caution.

Ernst Fischer, *The Necessity of Art*, Verso, 2010
Originally written in German in 1959, this meditation on the purpose of art by an Austrian writer may be anachronistically Marxist in outlook, optimistically proclaiming a Communist future, but it is also incredibly prophetic, predicting a diversion of styles and superabundance of production. Unafraid to ask the big questions of art's importance for humankind, it is perhaps unsurprising that the new foreword is by kindred left-leaning spirit John Berger.

Alex Danchev (ed.), *100 Artists' Manifestos: From the Futurists to the Stuckists*, Penguin, 2011
A good introduction to modern art's combative, reactive nature, in which subsequent twentieth-century movements or groups of artists rejected their forebears through strident calls-to-arms or poetic texts, this selection includes more recent examples too, such as Takashi Murakami's 'Super Flat Manifesto' which conflates a global Pop attitude with a youthful, alienated Japanese sensibility.

Hal Foster, *The First Pop Age: Painting and Subjectivity in the Art of Hamilton, Lichtenstein, Warhol, Richter and Ruscha*, Princeton University Press, 2012
Hal Foster, *The Art-Architecture Complex*, Verso, 2011
These two books by the same American art historian, Hal Foster, skirt the line between criticism and theory, between education and entertainment. Delivered as lectures or treatises on individual artists or as stylistic commentaries, the texts are lively and erudite exemplars of academic writing on recent art, with some interesting propositions about how culture is increasingly becoming an 'experience economy' (indeed, his chapters on this theme have helped me to form my ideas on 'Art as Spectacle').

Yve-Alain Bois, Benjamin Buchloh, Hal Foster and Rosalind Krauss (eds), *Art since 1900: Modernism, Antimodernism, Postmodernism*, Thames & Hudson, 2004
Inviting the four heavyweights of art history to rewrite the last century in their own images, marking every year with one momentous work or innovation, resulted in this indispensable account of the period. Although, like most books in this list, it doesn't tackle the last decade in any way, the entries give invaluable insights into how contemporary art came to be where it is now, albeit enlightening the reader through the prism of the past, rather than via the present – as I have attempted to do.

Daniel Birnbaum, Cornelia Butler, Suzanne Cotter, Brice Curiger, Okwui Enzwezor, Massimiliano Gioni, Hans Ulrich Obrist and Bob Nickas, *Defining Contemporary Art – 25 Years in 200 Pivotal Works*, Phaidon Press, 2011
Charting the period from 1986 to 2010, this scattershot work asks individual critics and curators to pick favourite or landmark pieces that might add up to a canon of the contemporary. Largely successful, it borrows the annual structure of *Art since 1900* and covers a lot of ground while highlighting some truly iconic works, such as Peter Fischli and David Weiss's famous short film *The Way Things Go* (1987), which features a chain reaction of everyday objects tipping over, rolling and falling over like dominoes.

Laura Hoptman, Yilmaz Dziewior and Uta Grosenick (eds), *The Art of Tomorrow*, Distanz, 2010
Many contemporary art books take the form of lengthy alphabetical lists of artists and so inevitably drift out of date, a risk anyone writing about such a moveable feast must face. However, this title managed to stay marginally ahead of itself with a very canny selection of younger artists, fully deserving its prophetic title.

Michael Wilson, *How to Read Contemporary Art*, Thames & Hudson, 2013
Having steered clear of the artist-by-artist model myself, this is another recent and successful example of a sweeping survey of contemporary practice. While it fails to deliver on the promise of its title, its author does provide a consistent and engaging tone in discussing such a vast range of makers (175 in total), ensuring its usefulness for a good few years to come.

ACKNOWLEDGEMENTS

With apologies to John Berger, this book is dedicated to, and indeed squarely aimed at, another radical visionary altogether, my father, John Ward, without whose wise words of encouragement and guidance this endeavour would never have been possible. Thanks go also to the publishers, my editor, Robert Shore (for understanding the napkin pitch), the designer, Jon Allan, the picture editor, Peter Kent, and all the galleries, artists and institutions that agreed to lend images to illustrate my ravings, not least the Lisson Gallery.

The genesis of this book came from my time as the first writer in residence at the Zabludowicz Collection's Finnish outpost of Sarvisalo on the island of Loviisa in 2012, for which I am eternally grateful – not only for the hospitality and generosity that the whole organization showed me – but in their faith and support for the project from start to launch. I would also like to acknowledge Vincent Honoré and the David Roberts Foundation for providing these ideas with an early intellectual forum in the guise of a symposium around the act of looking harder. Last, but by no means least, I would like to thank my family (I, I and I) for enduring six weeks in the wilds of Finland and then the best part of a year in the making of this book.

PICTURE CREDITS

6 Courtesy: Johann König, Berlin and 303 Gallery, New York. Photo: Vancouver Art Gallery
8 Thomas Demand, © DACS 2013. Courtesy Sprüth Magers Berlin London
13 Courtesy The Approach
14 Courtesy White Cube and Matthew Marks Gallery
15 © the artist, courtesy Maureen Paley, London
16 Courtesy Lisson Gallery
17 Courtesy of the artist and Metro Pictures, New York. Photo: Farzad Owrang
18 © Elad Lassry. Courtesy White Cube
19 Courtesy of Sprüth Magers Berlin London
23 Andrew Crowley/Camera Press
24 Photo: Todd-White Art Photography. Courtesy White Cube, London and Paula Cooper Gallery, New York
27 Courtesy Martin Creed
29 Carsten Holler, © DACS 2013. Photo by Peter Macdiarmid/Getty Images
31 Carsten Holler, © DACS 2013. Photo © Eloy Alonso/ Reuters/Corbis
34 Paul Pfeiffer, courtesy the artist and Thomas Dane Gallery, London
36-37 Daniel Buren © DB-ADAGP Paris and DACS, London 2013. Photo courtesy the artist
39 Courtesy the artist and gb agency, Paris; Arratia Beer, Berlin; Dvir Gallery, Tel Aviv
41 Courtesy the artist and gb agency, Paris. Photo: Giasco Bertoli
43 Jeremy Deller, *Sacrilege*, 2012. Courtesy of the artist. Photo: Angela Catlin
44 Courtesy Lisson Gallery
46 Thomas Hirschhorn © ADAGP, Paris and DACS, London 2013. Photo Romain Lopez, courtesy the artist
49 Thomas Hirschhorn © ADAGP, Paris and DACS, London 2013. Gladstone Gallery, New York, 2002
51 Photo courtesy the artist
52-53 Courtesy the artist and Hauser & Wirth. Photo: Fredrik Nilsen
54 © DACS 2013. Courtesy Sadie Coles HQ, London
55 © DACS 2013. © Photography Jan Bauer.Net/ Courtesy Jonathan Meese.Com
56-57 Courtesy the artist and Galerie Peter Kilchmann, Zurich
59 Jenny Holzer © ARS, NY and DACS, London 2013
60 George Condo © ARS, NY and DACS, London 2013. Courtesy of the artist and Simon Lee Gallery, London/ Hong Kong
61 courtesy Sadie Coles HQ, London
62-63 Courtesy: Johann König, Berlin and 303 Gallery, New York. Photo: Ludger Paffrath, exhibited at Johann König, 2005
65 Courtesy White Cube
66-67 © ADAGP, Paris and DACS, London 2013. Courtesy the artist and David Zwirner, New York/ London

INDEX